IMAGES
of America

SPRINGFIELD
VOLUME I

IMAGES
of America

SPRINGFIELD
VOLUME I

Ginger Cruickshank

ARCADIA

Published by Arcadia Publishing,
an imprint of Tempus Publishing, Inc.
2 Cumberland Street
Charleston, SC 29401

Printed in Great Britain.

Library of Congress Catalog Card Number applied for.

For all general information contact Arcadia Publishing at:
Telephone 843-853-2070
Fax 843-853-0044
E-Mail arcadia@charleston.net

For customer service and orders:
Toll-Free 1-888-313-BOOK

Visit us on the internet at http://www.arcadiaimages.com

Dedicated to Chuck, Adam, Jess, and Seth

CONTENTS

ACKNOWLEDGMENTS

I would like to take this opportunity to thank the countless people and organizations who have lent me their support, encouragement, and precious photographs. To my family, I owe immeasurable thanks for the inconvenience I caused in their lives and for their willingness to not only tolerate it, but to assist me in making this book happen. They are, as follows: my husband Chuck, who spent countless hours driving all over the city, picking up and returning pictures; my son Adam, who assisted with research and did all my computer input; my daughter Jessie, who assisted with picture selection and layout; and my youngest son Seth, who kept me smiling. Thank you. I would also like to acknowledge the following people, as well as anybody not included here, who offered input, support, information, and pictures. They are, as follows: Sherrilynn Asline, Xenophon A. Beake, Ramon Blood, Joyce Braithwaite, Dru Bronson-Geoffroy, Kathy Brown, Irene Cairns, Barbara Campanella, Mike Carney, Sister Mary Carr, Tony Catalfomo, Athan "Saco" Catjakis, Debbie Chappell, Rita Coppola, Gail Cosby, Louis Cote, Elizabeth M. Daly, Mallaci Fallon, Frank Faulkner, Russell Finer, Douglas Goodhue, Larry Gormally, Father Zachary Grant, Jean Graziani, Mike Graziano, Nancy L. Griffin, James P. Gurzenski, Anne Hatchett, Dr. John Howell, William Hughes, Maggie Humberston, Susan Johnson, Edward S. Kamuda, Captain Mark Kenney, Sister Maryanne Knolan, Michael Korzeniowski, Paula Lahey, James Langone, Fred LeBlanc, Karen D. Ledger, Lillian Lee, Robert McDonald, Father Paul Manschip, Mary Mastroianni, Carmen Morales, Wilfredo Moreno, James Munroe, Red Murphy, Hope Murray, Yolanda Nahorniak, Adrienne Nietupski, Dan O'Sullivan, Michele Plourde-Barker, Dorothy Pryor, Pat Reilly, Barbara Rivera, Fred Rodriguez, John Sampson, Rudi Scherff, Kathy Schwartz, Eleanor Seligman, Cantor Morton Shames, Gail Shapiro, Rose Shea, Enola Suffriti, Dan Sullivan, Teddy Sylvester, Amy Sutton, Pat Taylor, Victor Tondera, Pat Triggs, Helen Van Tassel, George Varelas, Joyce Watts, David Webb, and Father Stan Wszolek.

INTRODUCTION

As most histories about Springfield will tell you, William Pynchon and seven other men bartered for the land that was to become the current city. It all began as Agawam Plantation, and, since then, Springfield has gone through many changes and growing pains. What stands out, however, is the remarkable strength, resilience, and ingenuity of its citizens. A rich past tells the story of manufacturing, cultural, and social accomplishments that have earned the city the reputation as "the city of firsts."

What I have attempted to do with this book is to pay tribute to the people who were, and are, the fabric of Springfield's exciting story. Beginning with the founder and the early citizens of the 1600s, and including immigrants from every corner of the world, they and their descendants became the inventors, business founders, church leaders, laborers, educators, and public employees of Springfield. Without them, this city would not have its unique blend of charm and tenacity, and it could not have survived the difficult times, which tore apart other cities that were never able to make a full recovery.

Springfield deserves to be proud of its heritage and history, and based on all I have learned throughout this project, it will continue on its path to a bright and strong future.

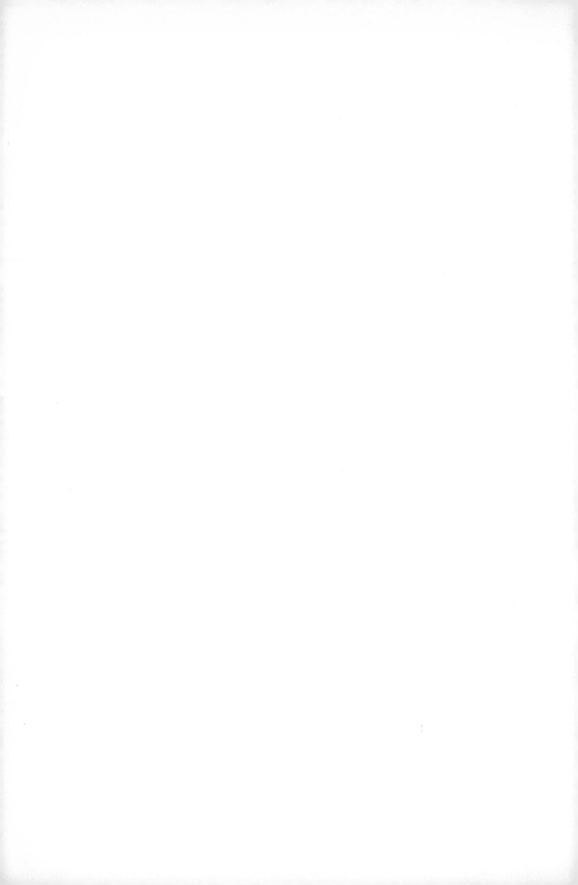

One

THE EARLY YEARS

Early maps show the Connecticut River as the most convenient way to travel, since few roads were in place then. The river was used by William Pynchon to ship furs and bring goods to the settlement. Along its banks, the future city was scattered with marshes, streams, some fertile ground, and pine barrens. (Courtesy of the Connecticut Valley Historical Museum.)

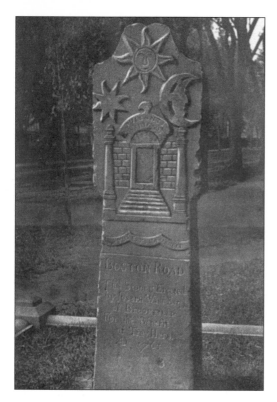

This stone, erected by Joseph Wait in 1763, attests to the travel made along this road between Boston and Springfield. Many of the city's earlier settlers came to the plantation from Boston on foot, which usually involved a two-week trek that covered 100 miles. (Courtesy of National Park Service, Springfield Armory NHS, Springfield, MA; 674-SA.a.1.)

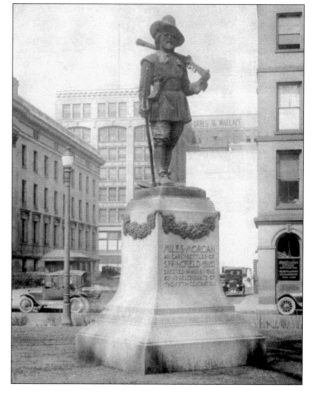

This statue of Miles Morgan, an early settler, was erected as a tribute by a fifth-generation descendant of his. The Forbes & Wallace Department Building can be seen in the background, and it is interesting to see, even then, the somewhat crowded parking conditions along the city streets. (Courtesy of Ramon Blood.)

Members of the Pynchon family are shown here on December 1, 1927, at the dedication of the Pynchon Memorial Building. William Pynchon is considered to have founded Springfield in 1636. Pictured in the front row, from left to right, are as follows: Mrs. Stafford Hendricks, daughter of George Pynchon 9th; Mrs. George M. Pynchon Jr. (10th); and Mrs. Harold Pynchon, mother of William Pynchon 11th. In the back row, from left to right, are Mrs. Cora Pynchon Mallory, sister of George M. Pynchon 9th; George M. Pynchon 9th; and George M. Pynchon Jr. (10th). (Courtesy of Connecticut Valley Historical Museum.)

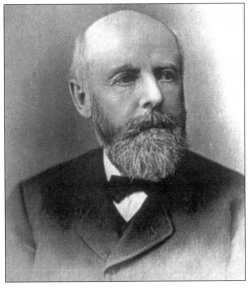

William L. Smith, lawyer, democrat, and twice president of the Common Council, was elected mayor in 1870. He pledged allegiance to "The laws of business and of common sense." In upholding that vow, he cut appropriations by 25% and held them steady in 1871, thereby balancing the budget for the first time in years. He was elected to the State Senate in 1872. (Courtesy of Connecticut Valley Historical Museum.)

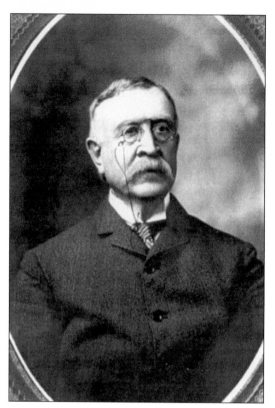

Samuel B. Spooner succeeded Smith in 1872 and continued his plan by backing the initiation of annual appropriations to reduce the debt. However, grandiose projects of the growing city doubled the expenditures so that by 1873, the debt was 1.1 million, and by 1875, it was 2.5 million. (Courtesy of Connecticut Valley Historical Museum.)

In the late 1800s, the city's Catholics launched a boycott of stores and businesses that had a policy of firing any person who refused to work on Christmas. The action was effective. It showed the determination of this group and also paved the way for the election of William P. Hayes as the first Irish-Catholic mayor of Springfield. (Courtesy of Connecticut Valley Historical Museum.)

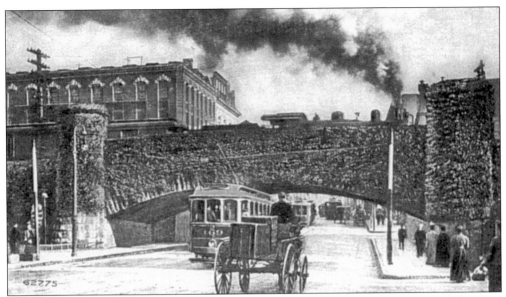

When the railroad arch was built in 1890 to alleviate the dangerous situation of the train directly crossing Main Street, many believed that it would isolate the North End from the downtown area in Springfield. To end squabbles that spanned 20 years over the bridge's construction, the Boston & Albany Railroad built the bridge, and the city excavated the underpass to four feet below street level. (Courtesy of Victor Tondera.)

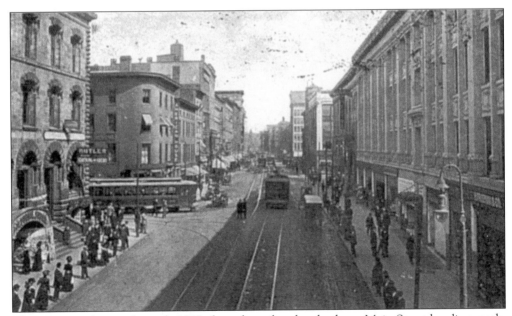

This picture, taken in the early 1900s from the railroad arch, shows Main Street heading south. The Massosoit Building, on the right, had just been built, and because of its proximity to the train station, it became a very popular hotel. (Courtesy of Victor Tondera.)

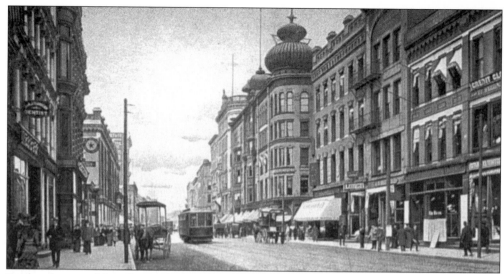

Further down on Main Street, the "Onion Building" can be seen on the right. So-called because of its onion-shaped dome, it was built in 1889 on the corner of Main and Bridge Streets. It was modern for its time, and the top floor boasted apartments for rent. (Courtesy of Karen D. Ledger.)

The congestion of a busy city is clearly visible in this photograph, c. 1908. Car no. 51 of the Hartford & Springfield Street Railway Company is heading for Court Square. It would then return to Hartford via West Springfield; Agawam; Suffield, Connecticut; and Windsor Locks, Connecticut. (Courtesy of Larry Gormally.)

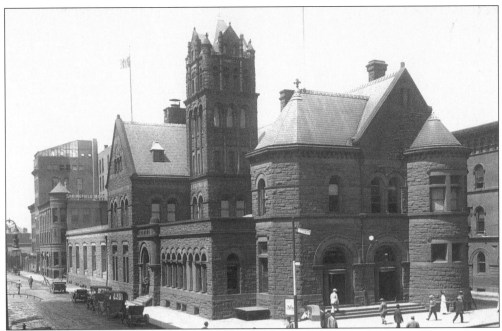

The old Springfield Post Office and Customs House was built in 1899, on the corner of Main and Worthington Streets. To the left of the picture, the glass top of the L-shaped block can be seen. The glassed-in area was a studio for the Springfield Photo Engraving Company. (Courtesy of Larry Gormally.)

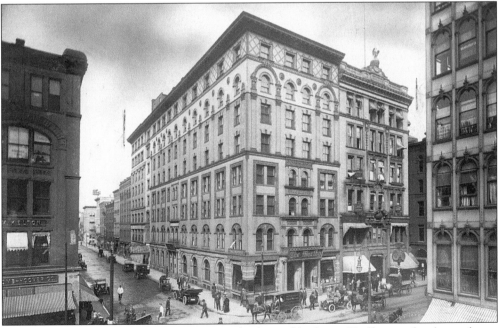

An interesting mix of transportation is clearly visible here. Trolley tracks, horse-drawn carriages, and motorized vehicles were all being used in the city at this time. The Worthy Hotel is located on the corner of Main and Worthington Streets. Built in 1895, it was a beautiful and popular spot for many years. (Courtesy of Larry Gormally.)

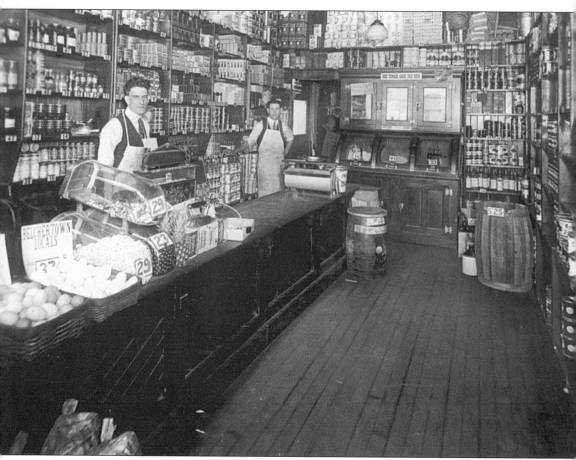

As the city became more populated, businesses opened to keep up with the need for goods and services. The A.H. Phillips Grocery Store was at the corner of Wilcox and Main Streets in the South End. Pictured, from left to right, are Fred Monica and John Topoloski. (Courtesy of Larry Gormally.)

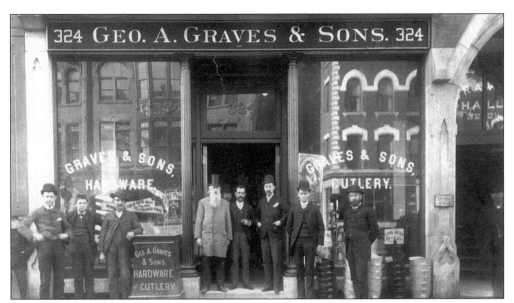

The George A. Graves & Sons Hardware Store was located at 324 Main Street, in the South End, which was inhabited primarily by Italian immigrants. (Courtesy of Larry Gormally.)

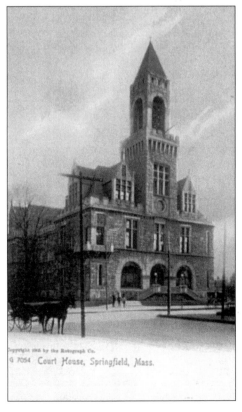

Hampden County Court House, a stately building, was designed by architect H.H. Richardson, who also designed the Church of the Unity and the North Congregational Church. He planned this stone structure in the shape of the Capital letter "I." Located off to the side of Court Square, it was originally planned to be built on upper State Street. (Courtesy of Victor Tondera.)

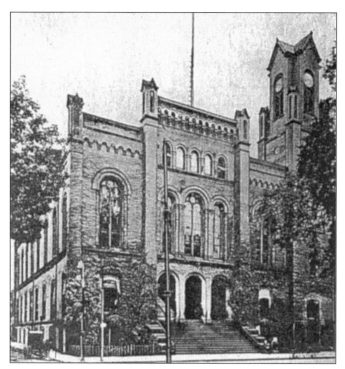

Springfield's old city hall was destroyed by fire on January 6, 1905. According to legend, a monkey, which was in the building's exhibition hall for a fair, overturned a kerosene lamp. (Courtesy of Karen D. Ledger.)

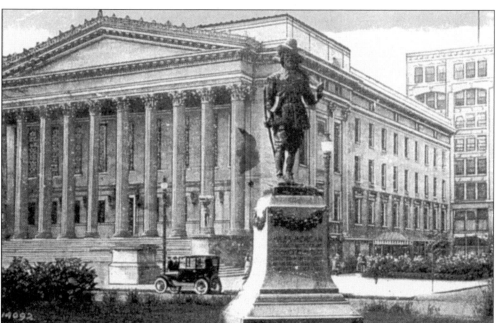

The new city hall, rebuilt as part of a municipal group, included an auditorium and a campanile. Dedicated in 1913, the buildings are a blend of Greek and Roman architectural styles. Twenty-seven varieties of marble, Cuban mahogany, and teakwood were used in the construction. A building commission, from many segments of the community, reviewed 82 designs. The chosen entry was from Corbett and Pell of New York City, who went on to design Rockefeller Center. (Courtesy of Karen D. Ledger.)

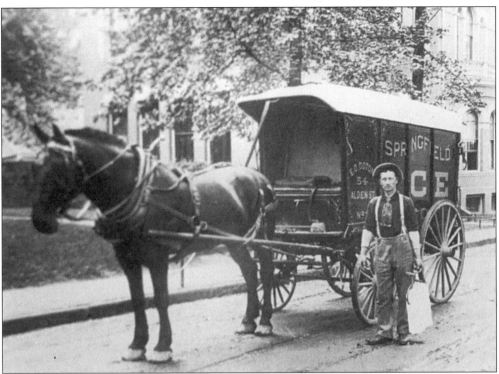

This photograph, *c.*1900, shows an employee of the Springfield Ice Company with a block of ice in his tongs. It was the city's largest ice company until it closed its doors during the 1930s. (Courtesy of Larry Gormally.)

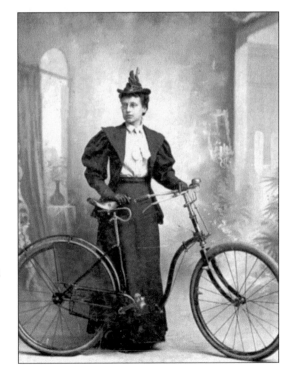

Victorian ladies often experimented with new and stylish forms of exercise. This woman shows off her new bicycle, complete with a bell and a low bar to accommodate her skirts. She is in the proper riding outfit, including gloves to protect her hands from calluses.

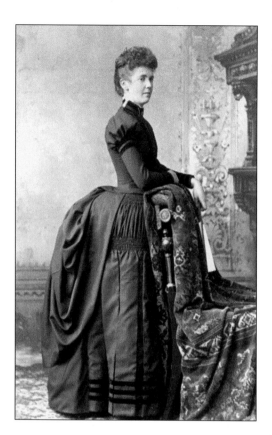

Clothing at the turn of the 20th century followed the fashion of the large cities, particularly New York City. This woman strikes a stately pose while modeling her silk gown and bustle.

Children's dress clothing was fussy during the Victorian period. Dresses were starched and uncomfortable, and girls always had large bows in their hair. These children pose on the family porch in downtown, c. 1899.

Two
SPRINGFIELD'S MELTING POT

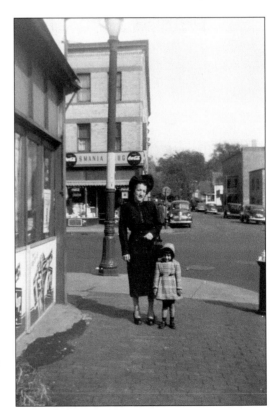

Springfield is composed of many neighborhoods, most of which were originally formed by specific ethnic groups. Today, although many of the first immigrants' descendants remain, the composition and diversity of each section of the city has evolved and changed with the times. The South End has long been considered the heart of the city's Italian community. Posing on their way to church, in the mid-1940s, are Helen Grasso and her niece, Candy Langone Blichfeldt. (Courtesy of James A. Langone.)

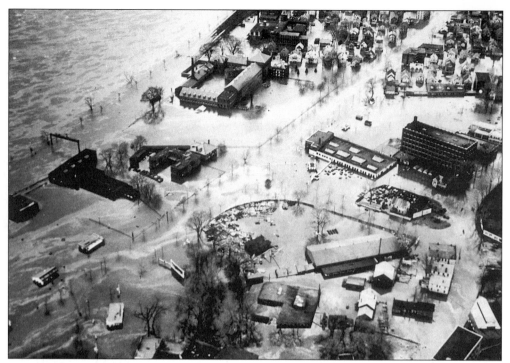

The flood of 1936 was caused by three inches of torrential rain on March 11, combined with the thawing of ice and snow. This aerial view shows the devastation caused in the South End by the Connecticut River's water. (Courtesy of James A. Langone.)

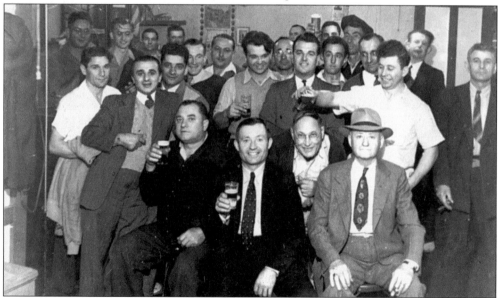

Ethnic groups usually developed parishes, built churches, and then formed social organizations to enjoy time and relaxation with people who shared the same language and customs. This photograph from 1942 shows a farewell party at the Adriatic Club, an Italian social club, given for Don Battisti before he left to participate in World War II. He is located in the third row, second from the left. (Courtesy of the Adriatic Club.)

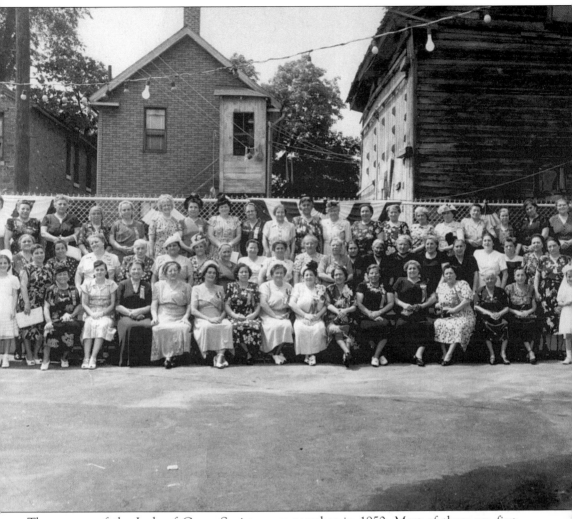

The women of the Lady of Grace Society pose together in 1950. Most of them are first-generation Italians. This society is no longer active. (Courtesy of James A. Langone.)

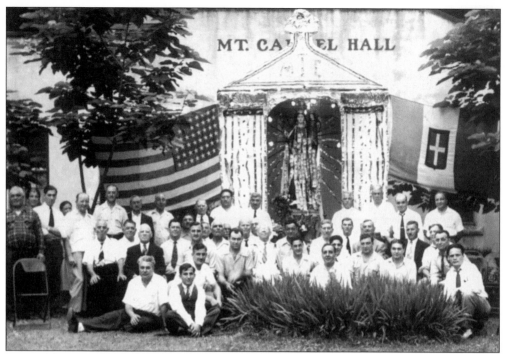

Pictured here are men of the Mount Carmel Society, an Italian social organization, founded in 1897 to bring together men of Italian descent for social and religious functions. (Courtesy of James A. Langone.)

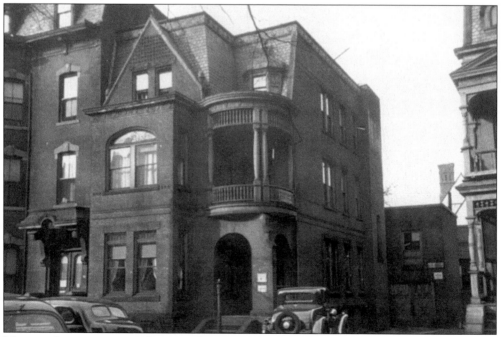

Matoon Street, now an historic district, contains exquisitely restored brick Victorian townhouses. Shown here in 1939, they were primarily lodging houses for the downtown community. (Courtesy of the Springfield Building Department.)

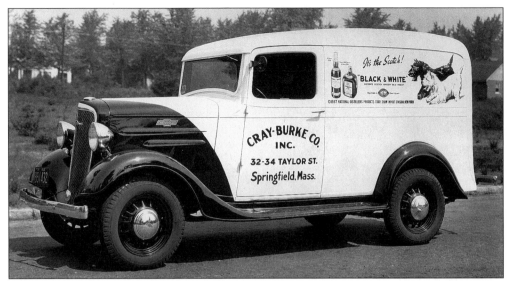

The Brightwood neighborhood was developed by George C. Fisk, president of Wason Manufacturing Company. Mr. Fisk planned 12 streets, which were to include businesses, homes, and a school. His home, which he bought in the Atwater area overlooking his development, was called "Brightwood" by its previous owner. Inspired, Fisk named his new complex the same. This Cray-Burke Company truck is pictured in the 1930s. The Cray-Burke Company still exists in Brightwood today. (Courtesy of Jean Graziani.)

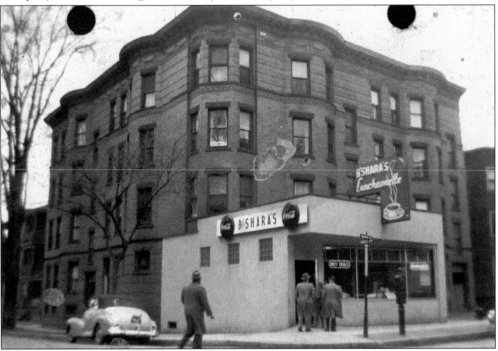

B'sharas Restaurant is pictured, c. 1946, in Brightwood at the corner of Main and Grace Streets. The restaurant was started by a Lebanese man, B'shara B'shara. His grandson now runs the business, which relocated to West Springfield after a fire destroyed the original building. (Courtesy of Paul B'shara.)

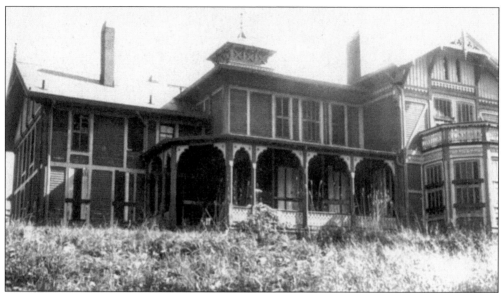

Atwater, which is located above Brightwood and near the Chicopee city line, has a delightful park-like atmosphere. Many of the city's prominent residents built spacious homes in Atwater at the turn of the 20th century, and most remain in excellent condition. This Gable-style house, photographed in 1932, was demolished in 1940. (Courtesy of Springfield Building Department.)

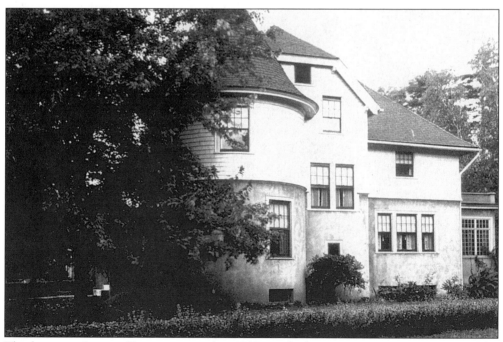

This home on Atwater Terrace, pictured in 1932, was built in 1914. Prior to 1860, most of the city's population lived within a 1.5-mile radius of downtown. As the population grew and new immigrants moved in, some descendants of earlier citizens moved to newer residential sections. (Courtesy of Springfield Building Department.)

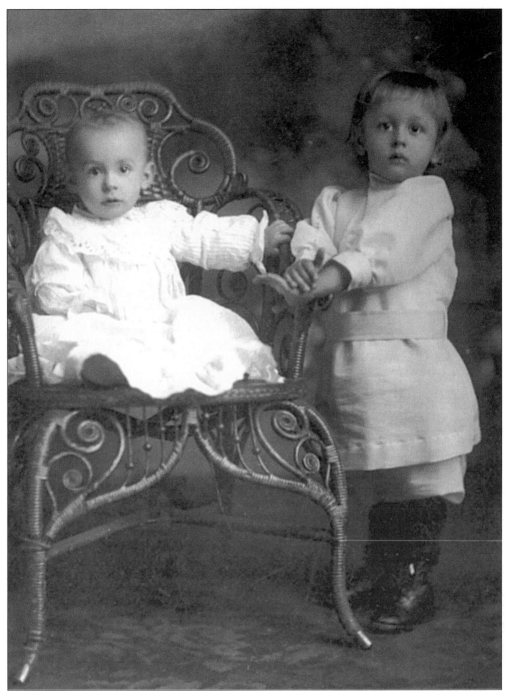

Immigrants from Poland arrived in the late 1800s and settled in Chicopee, Ludlow, Indian Orchard, and the North End of Springfield. Many organizations formed to assist in providing health and life insurance benefits and financial support for its members. The H.L. Handy Company employees, many of whom were Poles, formed a mutual benefit society around 1900. These children of a Handy employee are pictured *c*. 1917. They are Maxine and Julian Zabecki (the author's father).

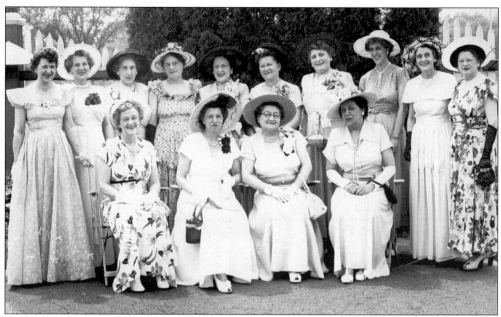

French-Canadians moved into the city and settled in both the North and South Ends. The ladies of the Saint Joseph's Social Club are shown at a gathering in the Wayside Restaurant, West Springfield. The "Dames de la Paroisse" was one of many French social clubs. (Courtesy of St. Joseph's Church.)

The first Greek immigrants came to Springfield around 1884. Eleftherios Pilalas was the first to arrive, and he worked at the Kibbee Candy Company. Greeks, like many others, immigrated for better opportunities and political freedom. In 1908, many young men came to this area to avoid forced induction into the Turkish army. The photograph, taken in 1947, is of the Greek Dramatic Club.

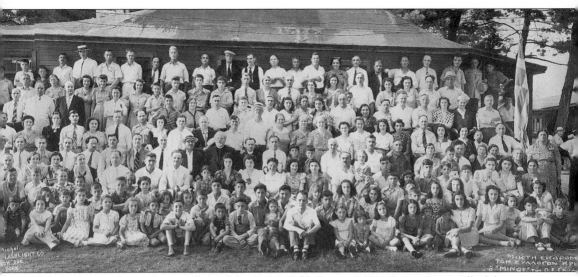

This 1940 view shows the members of the Springfield Cretan Society at a picnic. All of them are, or are the descendants of, people who immigrated to the area from the Island of Crete. This is the oldest chapter of the Pan Cretan Association of America.

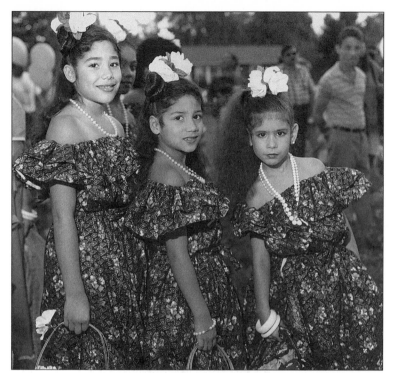

The makeup of the North End, like all the city's neighborhoods, continually changed. By the 1950s and 1960s, Hispanics, largely from Puerto Rico, began settling in the North and South Ends. These lovely Hispanic girls pose in traditional costume before performing the Plena, a traditional Puerto Rican dance, at the Puerto Rican Festival. (Courtesy of William Hughes.)

The passing down of traditions, customs, and celebrations from one generation to the next is important to all nationalities. Here, music store owner Wilfredo (Freddy) Moreno plays the conga drums with his son, Wifredo (Toly) Moreno Jr., at a festival. (Courtesy of William Hughes and Wilfredo Moreno.)

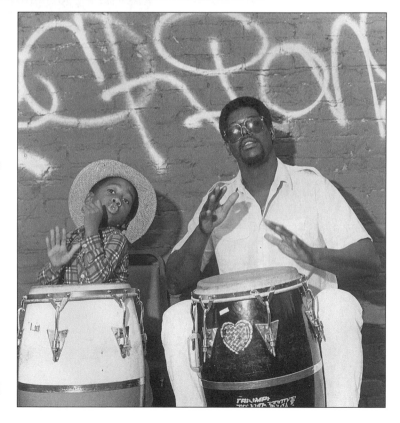

German craftsmen were hired at the Springfield Armory to meet the new demand to produce weapons after the Harper's Ferry arsenal was destroyed in 1862. The result was an expansion of the German community. In the city, the first Germans settled in the Cross Street area in the South End, but they soon moved north and east. Many businesses were started, including Steigers Department Store and the Student Prince and Fort Restaurant, which started in 1935. This plaque was placed at the restaurant to commemorate the Old Fort of 1660, which was on the same site. (Courtesy of Rudi Scherff.)

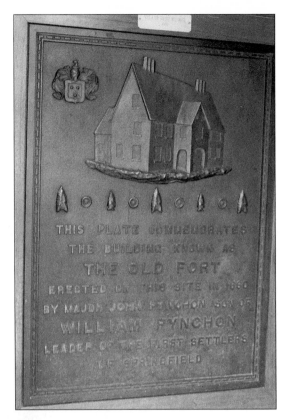

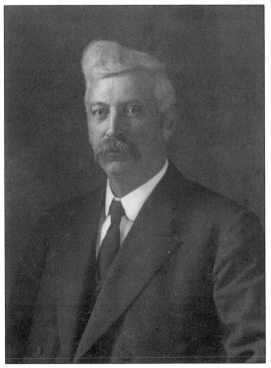

Many Irish people, escaping from the potato famine, had arrived by 1840. At first, they lived around the Depot in the North End, and then they moved up Carew Street to "Hungry Hill." Thomas P. Sampson, pictured here, was born in Ireland and came to America in 1865. In 1880, he started a funeral business that is still family-run today. Mr. Sampson's son married the daughter of Springfield's first Irish-Catholic mayor, William P. Hayes. (Courtesy of John Sampson.)

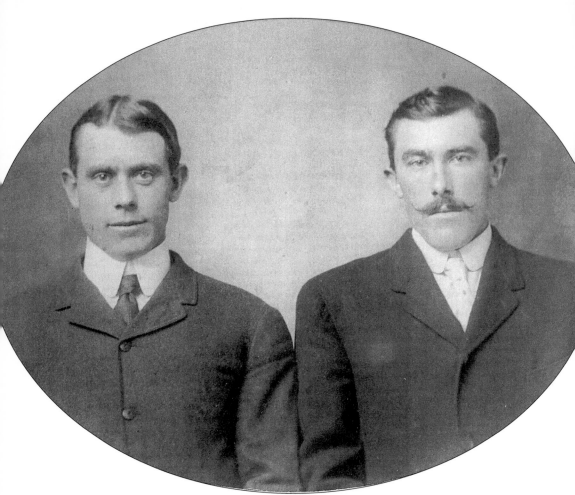

John Carney (left) and his brother Michael were photographed together in 1887. John left the Blasket Islands off of the coast of Ireland to secure work in Springfield with the Boston & Albany Railroads. Although John returned home, Michael chose to stay in this country. (Courtesy of Mike Carney.)

The Irish community in the Liberty Heights area continued to grow, establishing a church, a parochial school, and social organizations. As with most ethnic neighborhoods, life centered around the church, where masses were said in native languages. Mr. and Mrs. John G. Curley are shown with their family on Armory Street, returning home from church on Easter Sunday, 1950. (Courtesy of Mallaci Fallon.)

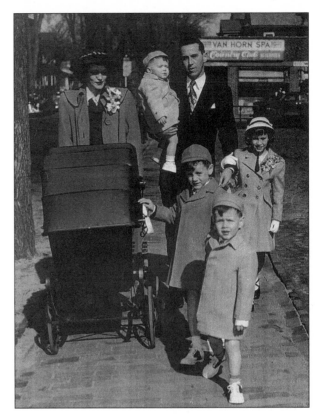

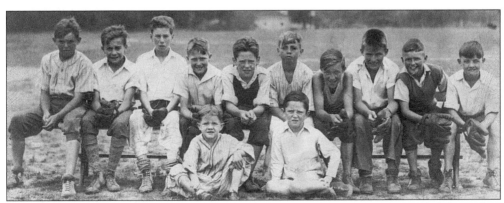

This group of local boys from Hungry Hill, shown at Van Horn Park in 1932, called themselves the Mooreland Eagles and were a 10-12 team. Pictured, from left to right, are as follows: (back row) Tossie Shea, Larry Turcotte, Harold Flavin, Don Dowd, Dede Murphy, Frank Masko, Juny Devine, Jack Sweeney, Lefty Keough, and Leo Lehr; (seated on the ground) Mac McKenzie and the future Father Henry Murphy. (Courtesy of Red Murphy.)

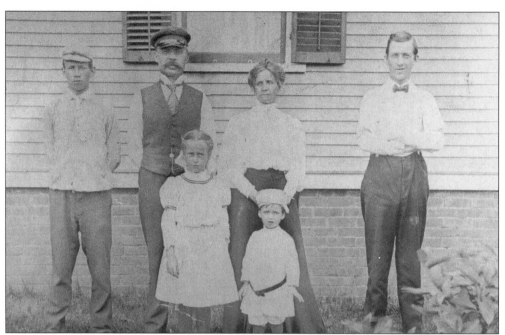

Ethnic groups other than Irish settled in smaller numbers on Hungry Hill. Many of the arriving Swedes were employed by the Hendee Manufacturing Company, later called the Indian Motocycle Company. This Swedish family pose outside their home on Carew Street, *c.* 1910. They are, from left to right, as follows: (front row) Esther Luthgren and Wilfred Luthgren; (back row) Oscar Luthgren, the author's grandfather, August Luthgren, Jennie Luthgren, and Adolph Luthgren.

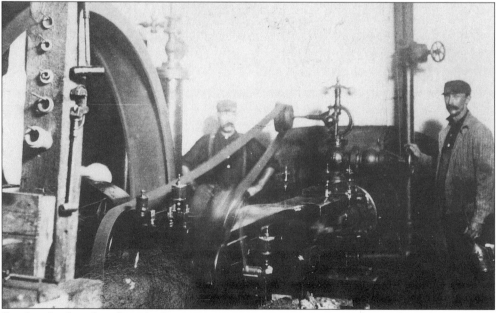

Swedes also found work in the Brownstone quarries in East Longmeadow and in other new and developing companies. These men were employed at what appears to be a boiler company, possibly the Oscar F. Carlson Boiler Setting Company.

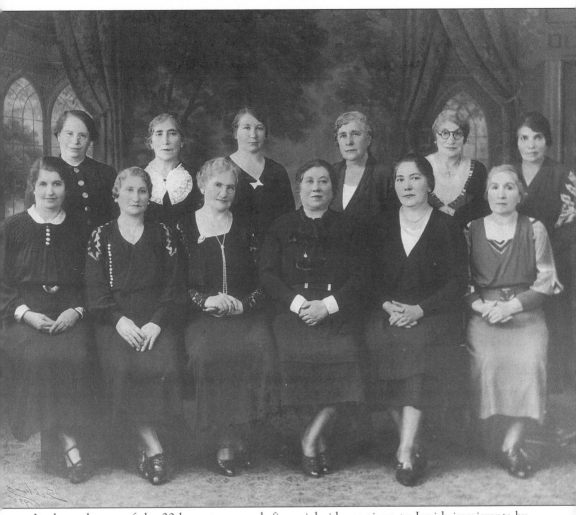

In the early part of the 20th century, much financial aid was given to Jewish immigrants by other Jewish citizens. Around 1907, most loans of this type became regulated with the formation of the Hebrew Free Loan Association. While men donated much of the money, it was the women who usually distributed this charity. The women of the society are pictured here in 1935. They are, from left to right, as follows: (front row) Mrs. Sofie Buckheim, Mrs. Lena Sherman, Mrs. Gussie Widlansky, Mrs. Ida Savitsky, Mrs. Bessie Levine, and Mrs. Lena Freedman; (second row) Mrs. Samuel Rickless, Mrs. Sarah Sisitsky, Mrs. Lena Baver, Mrs. Ida Cohen, Mrs. Mary Albert, and Mrs. Fannie Kingsberg. (Courtesy of Jewish Federation of Greater Springfield.)

The Young Men's Hebrew Association (YMHA) was organized in 1895 by Henry Lasker. This group helped to secure employment for immigrants from Poland and Eastern Europe. It also had a purpose of "elevating its members and the community by adapting them to the customs and institutions of the American people." Originally located on Worthington Street, the organization moved in 1921 to this location on Sargeant Street. (Courtesy of Jewish Federation of Greater Springfield.)

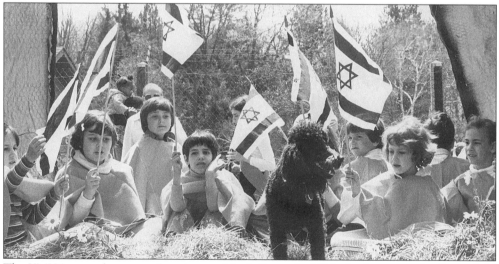

The YMHA moved to a new location on Maple Street in 1936. At that time, the Springfield Jewish Community Council was organized, and the YMHA, then called the "center," became one of its agencies. By 1949, the Jewish Community Center had become an autonomous agency, and on October 17, 1954, a new Jewish Community Center building was dedicated on Dickinson Street. This photograph shows children at an Israel Independence Day program. (Courtesy of Jewish Federation of Greater Springfield and Gail Shapiro.)

Black history in Springfield began as early as 1680. In 1754, the census listed 27 black people, and by 1970, the black community grew to 20, 673 people. Slavery came to an end in the city in 1808, when private citizens purchased the last slave and set her free. Young Charles Jackson, whose descendants still live in the area, strikes a commanding pose in the early part of this century. (Courtesy of Lillian Lee.)

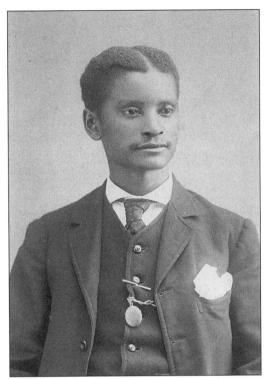

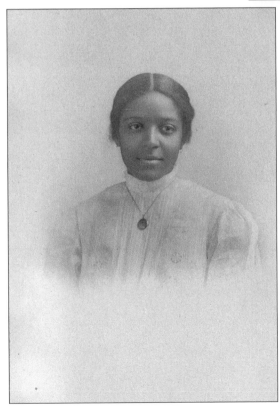

Elizabeth Jackson, the daughter-in-law of Charles (pictured above), is shown here in her high school graduation picture. She graduated from Springfield Central High School in 1906. She later married William Jackson, and they settled in a home on Monroe Street. Mr. Jackson was a former District Grand Master of the Odd Fellows, and in 1923, he was one of the first administrators of the All-Pine Camp, in Monson, for under-privileged children. (Courtesy of Lillian Lee.)

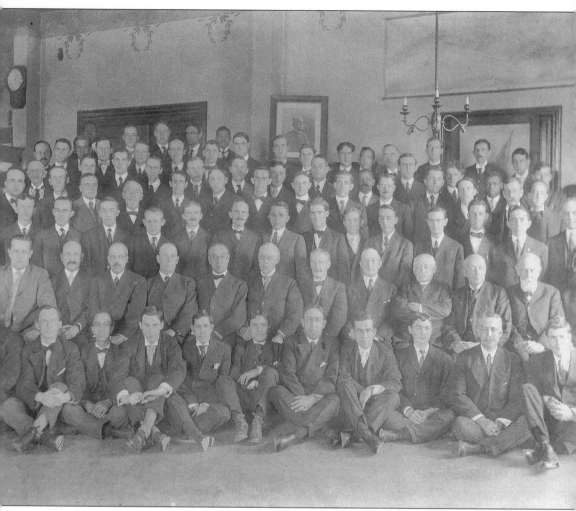

The Massachusetts Mutual Life Insurance Company hired many black people at the turn of the century. In 1907, members of the shipping department posed for this portrait. The identified people in the picture are as follows: William Jackson, front row, third from the left; Alexander Hughes, fifth row, with mustache; Arthur Gray, fifth row, second from the right; and Henry Phrame, back row, in front of the door at the right. (Courtesy of Lillian Lee.)

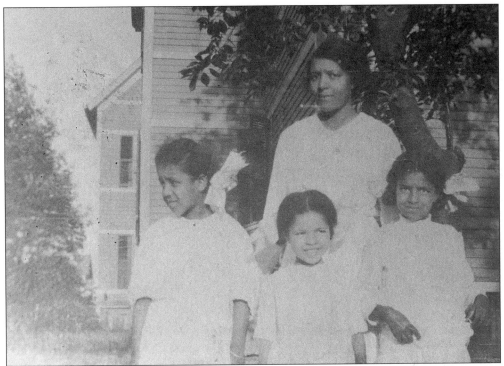

Elizabeth Walters Jackson (Bessie) poses in 1915 at the home of Rev. Garnett R. Waller, pastor of the Third Baptist Church. She is pictured with three of her daughters, Marion, Lillian, and Ruth. Elizabeth served as first lieutenant of Girl Scout troop no. 22, which was organized in 1918 at the Third Baptist Church. (Courtesy of Lillian Lee.)

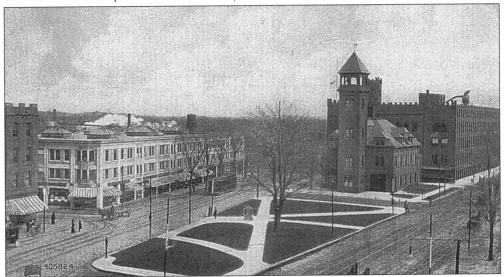

Directly east of Springfield's downtown is Winchester Square, which is now called Mason Square. This view shows the intersection of State Street and Wilbraham Road. The square was, at one time, home to the Knox and Hendee Companies. Originally named for Charles A. Winchester, a former mayor of Springfield, it now bears the name of Primus Mason, a prominent black man who sold the city much of its land. (Courtesy of Victor Tondera.)

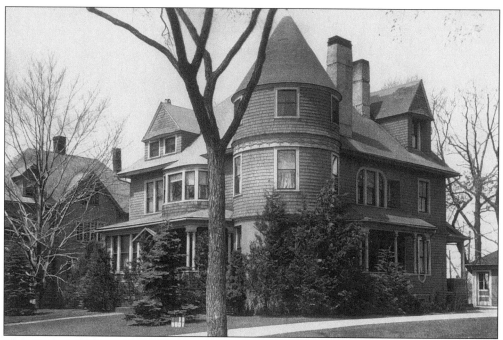

John D. and William H. McKnight were developers at the end of the 19th century. After purchasing a farm off State Street, they built close to 1,000 homes. This home, at Cornell Street, is pictured in 1938. The McKnights also turfed the lots and planted shrubs and trees for each property. (Courtesy of Springfield Building Department.)

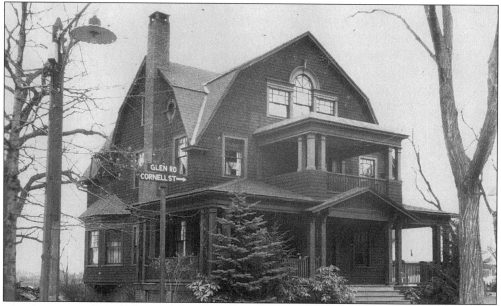

This home, viewed as it was in 1938, shows the size and complexity of the designs. After each street was completed, the builders then laid the sidewalks. The McKnights also built three small triangular parks with fountains. Considered the city's first "streetcar suburb," the McKnight neighborhood gave the city its reputation as the "City of Homes." (Courtesy of Springfield Building Department.)

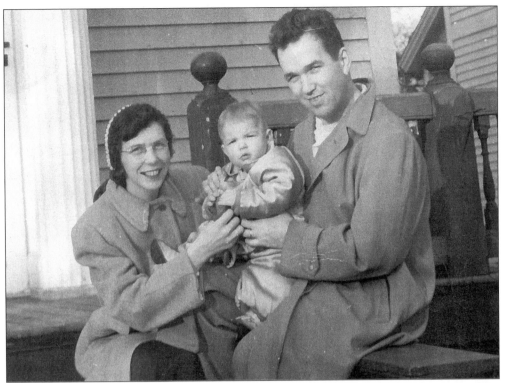

This charming image shows young David Gaby, with his parents in 1950, on the porch of the family home on Dartmouth Street. McKnight became an historic district in 1976, and a homeowners' association was formed in 1982. The residents of this neighborhood have succeeded in maintaining it as a very family-oriented place to live. (Courtesy of David Gaby.)

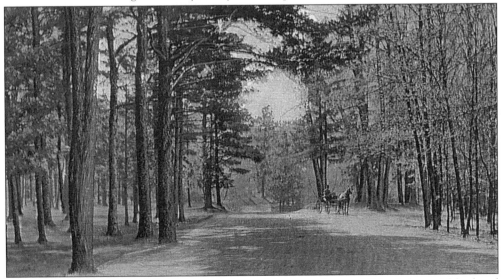

Forest Park, one of the largest and most beautiful city parks, established the neighborhood bordering it as one of the most fashionable places to live. This view, taken around the early-1900s, shows a rustic road through the park. Not long before, all of the area was woods, with only long Hill Street in place. (Courtesy of Victor Tondera.)

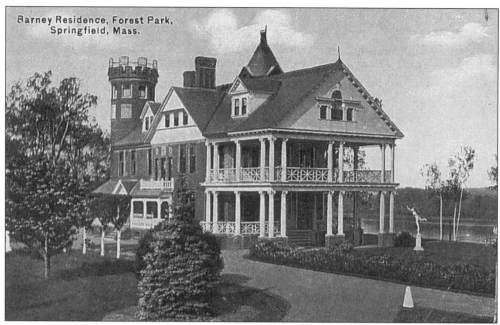

Everett Hosmer Barney was the inventor of the Barney and Berry Skate, which attached to footwear by metal clamps. In 1882, he purchased a 110-acre estate, and in 1883, he built Pecousic Villa. This set the tone for the grand homes in historic Forest Park Heights, which was the city's second "streetcar suburb." Pecousic Villa was demolished in 1959 to make way for the new Route 91. (Courtesy of Victor Tondera.)

The Barney carriage house was saved from destruction, and it has been beautifully restored and is used by the park department. John Lizak, of Palmer, was the builder of the villa and carriage house. The interior of the home was constructed with Italian tiles, bronze work, stained-glass windows, and panels of various woods. (Courtesy of Springfield Park Department.)

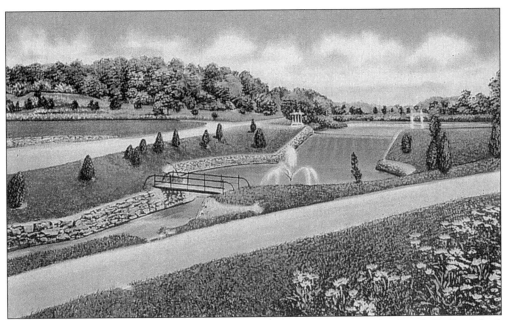

Mr. Barney's estate bordered a tract of land that was donated to the city by Orrick H. Greenleaf. These 70 acres became Forest Park, the city's first public park, in 1883. In 1890, Everett Barney gave 109.5 acres of his land, including these water gardens, to the park. (Courtesy of Victor Tondera.)

Forest Park, now more than 300 acres, became a focal point for people in the city. For many years, the zoo had crocodiles, a monkey house, tigers, lions, peacocks, and bears, among many other animals. The cost of upkeep closed the zoo, but today, a small privately run petting zoo is located in the park. (Courtesy of Springfield Park Department.)

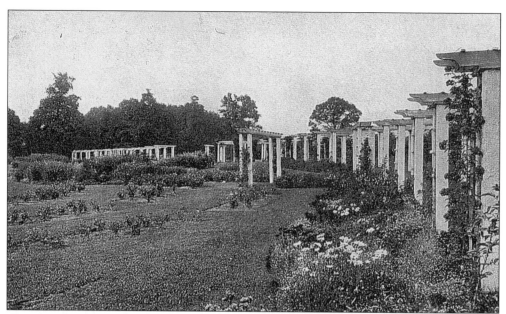

The Rose Garden in Forest Park, pictured around 1900, was a very popular attraction. People came to the park for picnics, boating, and to take peaceful walks. The garden added to the beauty of Mr. Barney's estate, which contained lotus and lily ponds, waterfalls, and numerous exotic shrubs and trees from China, India, and Europe. (Courtesy of Victor Tondera.)

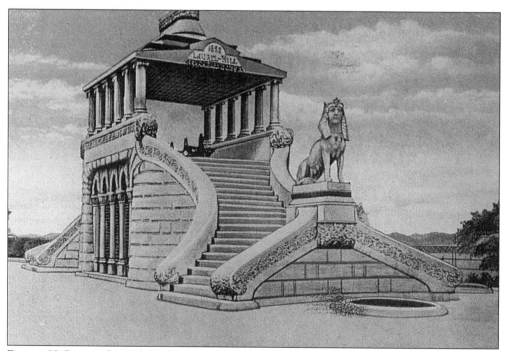

Everett H. Barney, his wife Katherine, and their son, George, are entombed in the Mausoleum on Laurel Hill in the park. The hill overlooks the beautiful Connecticut River. (Courtesy of Springfield Park Department.)

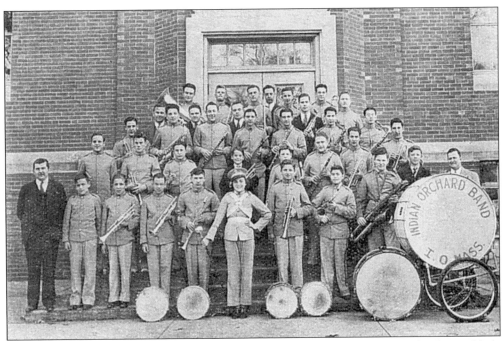

The Indian Orchard Band proudly poses in the mid-20th century. Indian Orchard most likely received its name because the tribes that originally lived there, in the 1600s, sold fruit to the settlers from their plum orchards. The Indian Orchard Canal Company began to build a planned industrial community to address the needs of employees at its linen and cordage factories. A mixed population of French-Canadians, Irish, Polish, Portuguese, and Armenians has developed over the years. (Courtesy of Karen D. Ledger.)

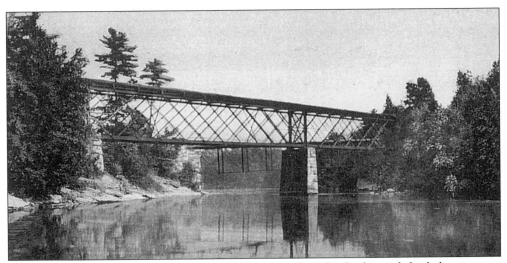

There are many legends about the name "Indian Leap," as this bridge and the ledges it spans from are called. One of the most popular is that Chief Roaring Thunder, of the Coughmanyput Tribe, ordered his people to jump off the cliffs into the Chicopee River below, to prevent capture by soldiers who were retaliating as a result of the burning of Springfield in 1675. The legend says that they then swam to caves and hid, later settling in Wilbraham. The bridge no longer exists. (Courtesy of Karen D. Ledger.)

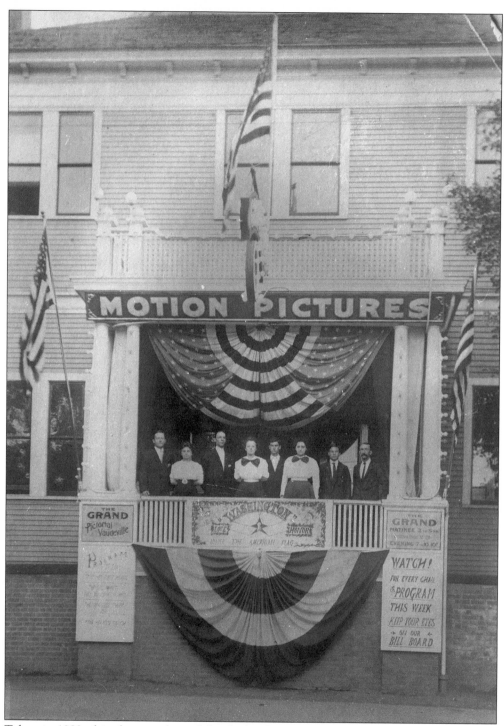

Taken in 1909, this photograph is of the Orchard's Grand Theater, which showed "pictorial vaudeville." An autonomous neighborhood for years because of its location, the community of Indian Orchard is still independent and civic minded. (Courtesy of Edward S. Kamuda.)

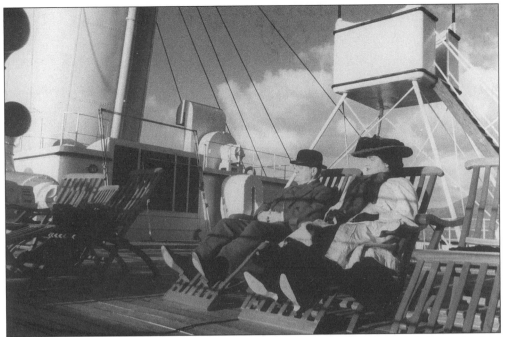

The Titanic Historical Society was founded in Indian Orchard in 1963. A global organization, it is dedicated to preserving the history of RMS *Titanic* and other great ocean liners. It was to this group that the producers of the blockbuster movie *Titanic* came for much technical expertise. Mr. and Mrs. Edward Kamuda are shown on the movie set, performing as first-class passengers. (Courtesy of the Titanic Historical Society.)

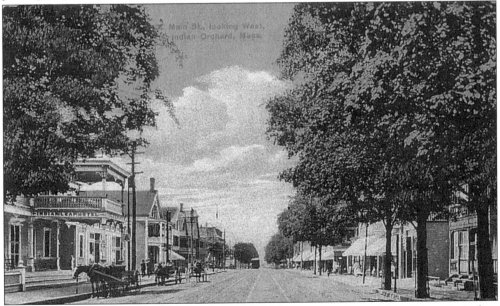

This photograph, dating from the turn of the 20th century, shows Main Street in Indian Orchard. Probably taken from Pine Vale Street, the picture shows the Indian Leap Hotel on the left. Built in 1873, it was one of four hotels that accommodated the many people who came to visit the successful mills in Indian Orchard. (Courtesy of Karen D. Ledger.)

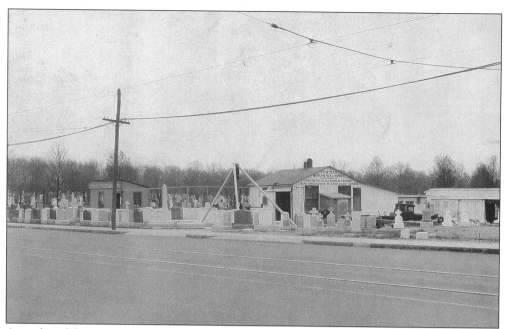

A truck and farming community at one time, Pine Point was first referred to as the Pine Plain because of the abundance of Yellow Pines. In 1871, the Catholic Diocese of Springfield purchased 83 acres of land here for St. Michael's Cemetery, and development of the area soon began. This picture, taken in 1929, shows the cemetery to the left and the Venezian Monument Works adjacent to it. Trolley tracks running up State Street are clearly visible. (Courtesy of Ramon Blood.)

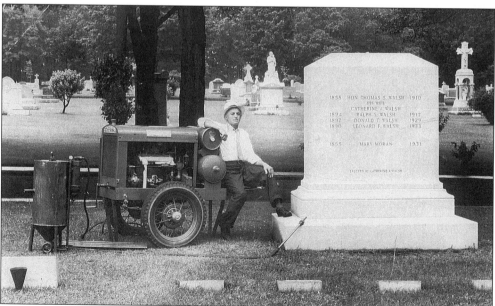

Before the invention of the sandblaster, the stone cutters at Venezian Monument Works did the difficult and time-consuming work by hand. The previous owner of the works, Roman Marandi, is shown inside St. Michael's Cemetery with his new sandblaster, in 1929. (Courtesy of Ramon Blood.)

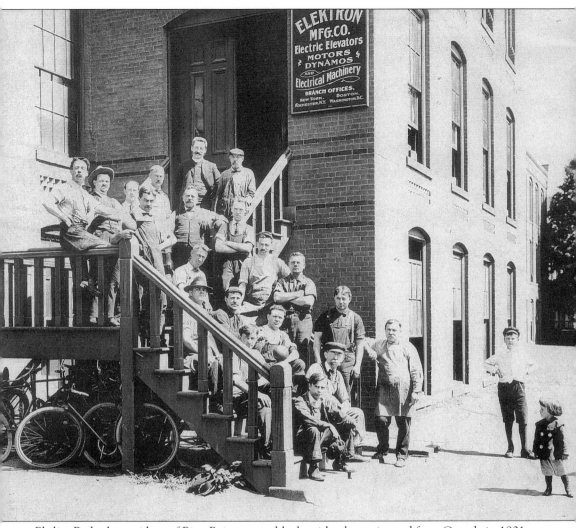

Philias Bedard, a resident of Pine Point, was a blacksmith who emigrated from Canada in 1901. This picture, *c.* 1908, shows Philias on the bottom set of stairs, standing with his arms folded in front of the brick wall of the Elektron Manufacturing Company, which no longer exists. (Courtesy of Patricia Bedard Triggs.)

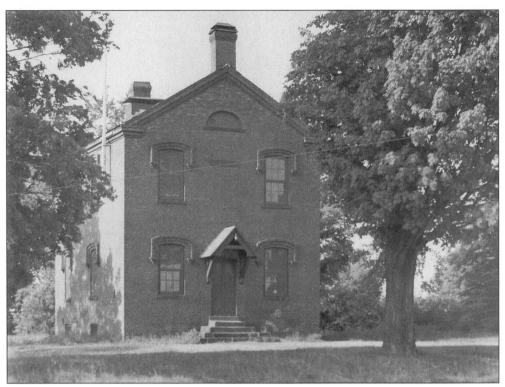

Sixteen Acres was a rural and isolated farming community until after World War II. Citizens Hall, erected in 1859, was an important center of the neighborhood since there was no public transportation to the Acres until 1936. The hall served as a school, church, theater, polling place, and clubhouse. It was demolished in 1960. (Courtesy of Larry Gormally.)

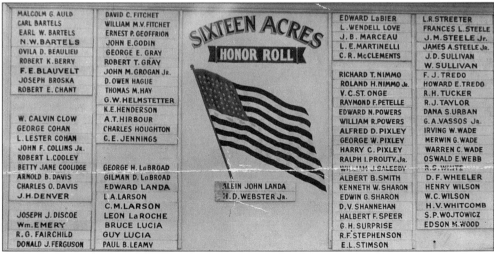

MALCOLM G. AULD	DAVID C. FITCHET	EDWARD LaBIER	L.R.STREETER
CARL BARTELS	WILLIAM M.V.FITCHET	L.WENDELL LOVE	FRANCES L.STEELE
EARL W. BARTELS	ERNEST P.GEOFFRION	J. B. MARCEAU	J.M.STEELE Jr.
N.W.BARTELS	JOHN E.GODIN	L.E.MARTINELLI	JAMES A.STEELE Jr.
OVILA D. BEAULIEU	GEORGE E. GRAY	C. R. McCLEMENTS	J.D. SULLIVAN
ROBERT K.BERRY	ROBERT T. GRAY		W. SULLIVAN
F.E.BLAUVELT	JOHN M.GROGAN Jr.	RICHARD T.NIMMO	F. J.TREDO
JOSEPH BROSKA	D.OWEN HAGUE	ROLAND H.NIMMO Jr.	HOWARD E.TREDO
ROBERT E.CHANT	THOMAS M.HAY	V.C.ST.ONGE	R.H.TUCKER
	G.W.HELMSTETTER	RAYMOND F.PETELLE	R.J.TAYLOR
	K.E.HENDERSON	EDWARD N.POWERS	DANA S.URBAN
W. CALVIN CLOW	A.T.HIRBOUR	WILLIAM R.POWERS	G.A.VASSOS Jr.
GEORGE COHAN	CHARLES HOUGHTON	ALFRED D. PIXLEY	IRVING W.WADE
L.LESTER COHAN	C.E.JENNINGS	GEORGE W.PIXLEY	MERWIN G.WADE
JOHN F. COLLINS Jr.		HARRY C. PIXLEY	WARREN C.WADE
ROBERT L.COOLEY		RALPH I.PROUTY.Jr.	OSWALD E.WEBB
BETTY JANE COOLIDGE	GEORGE H. LaBROAD	WILLIAM J.SALEEBY	R.C.WHITE
ARNOLD B. DAVIS	GILMAN D. LaBROAD	ALBERT B.SMITH	D. F. WHEELER
CHARLES O. DAVIS	EDWARD LANDA	KENNETH W.SHARON	HENRY WILSON
J.H.DENVER	L.A.LARSON	EDWIN G.SHARON	W.C.WILSON
	C.M.LARSON	D.V.SHANNEHAN	H.V.WHITCOMB
JOSEPH J. DISCOE	LEON LaROCHE	HALBERT F.SPEER	S.P.WOJTOWICZ
Wm. EMERY	BRUCE LUCIA	G. H. SURPRISE	EDSON M.WOOD
R. G. FAIRCHILD	GUY LUCIA	R.F.STEPHENSON	
DONALD J.FERGUSON	PAUL B.LEAMY	E.L.STIMSON	

SIXTEEN ACRES HONOR ROLL

ALEIN JOHN LANDA
H.D.WEBSTER Jr.

As the little community of Sixteen Acres grew, more families arrived, and a civic sense of pride developed. This memorial was erected to pay tribute to those from the community who fought in World War II. Pictured in the early 1940s, the honor roll of deceased soldiers eventually had more names added. (Courtesy of Joyce Braithwaite.)

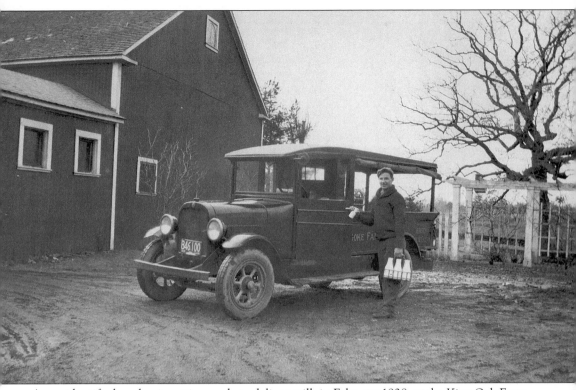

An unidentified worker is getting ready to deliver milk in February 1928, at the King Oak Farm in Sixteen Acres. The farm was located at the corner of South Branch Parkway and Parker Street. (Courtesy of Joyce Braithwaite.)

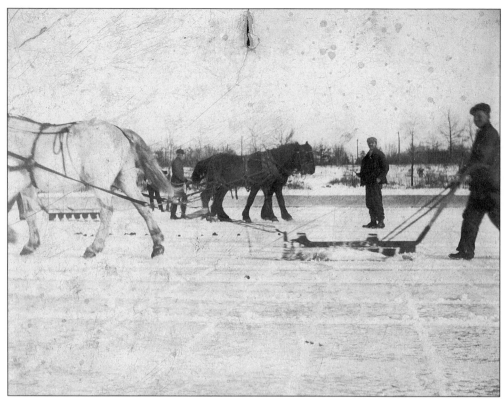

Pictured cutting ice on Mill Pond, in Sixteen Acres, is Edwin H. King and his father, Edwin P. King, in the early part of the 20th century. (Courtesy of Joyce Braithwaite.)

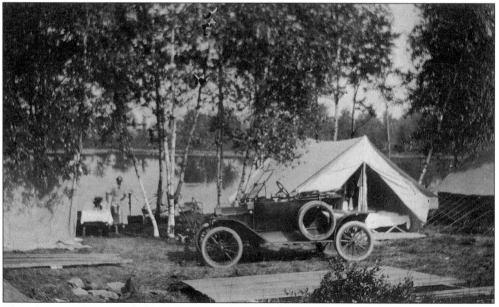

This photograph was probably taken around 1910. The rustic camp of the Littlefield family is shown on the shores of Venture Pond in Sixteen Acres. (Courtesy of Larry Gormally.)

Three
FAITH OF THE PEOPLE

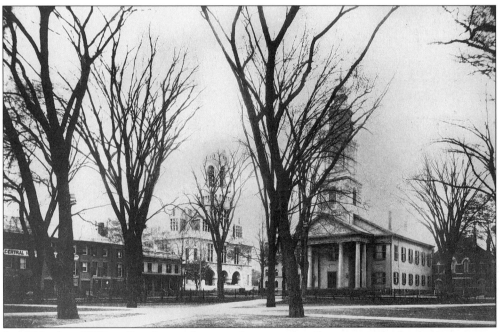

In 1636, when William Pynchon and seven other men signed an agreement for the government of their new settlement, they decided to procure a minister as quickly as possible. In 1637, Rev. George Moxon arrived from England and began the First Church of Christ congregational. This photograph, taken around 1882, shows the 4th meetinghouse of the congregation, which was built by Captain Isaac Damon of Northampton in 1818. Across from the church is the first city park, deeded to Hampden County in 1821 by Daniel Bontecou and Edward Pynchon, among others, who raised the money to buy the land. (Courtesy of First Church of Christ-"Old First Church.")

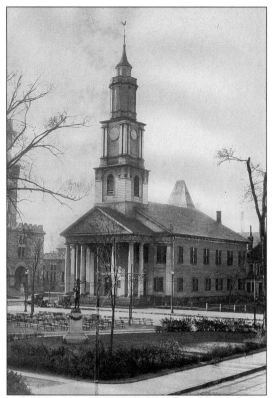

Seen atop this church spire is a 60-pound rooster weathervane, made by a coppersmith in England. It was originally placed on the 2nd meetinghouse before it was moved to the church. Co-founder William Pynchon was an educated and religious man, but after the publication of his book, *The Meritorious Price of Our Redemption*, which was considered heretical and ordered to be publicly burned in Boston, Pynchon believed that Massachusetts was not a safe place for his ideas. He returned to England with his wife and Pastor Moxon, never to return again. (Courtesy of First Church of Christ-"Old First Church.")

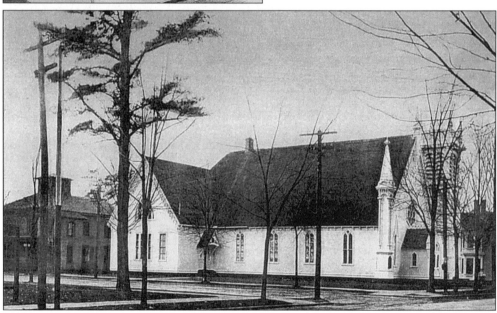

The Evangelical Religious Society of Indian Orchard worshiped in the Evangelical Church, which is pictured here around 1906. The Orchard is also home to the following churches: St. Matthew's Church, built in 1864; Saint Gregory Armenian Apostolic Church, built in 1934; Immaculate Conception Catholic Church, built in 1904; and Saint Aloysius Catholic Church, built in 1873. (Courtesy of Karen D. Ledger.)

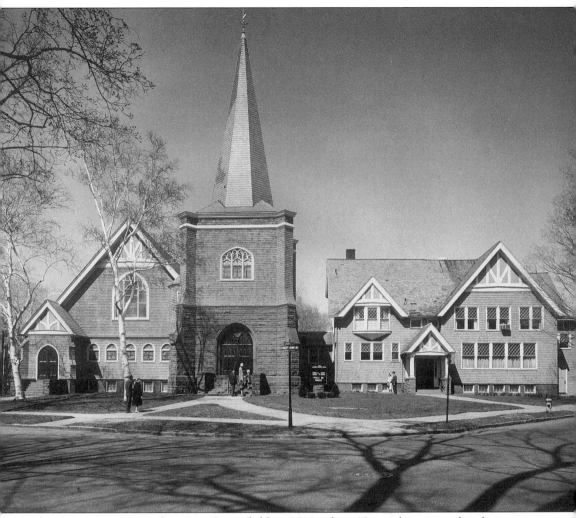

The Baptist community began in Springfield in 1811, when 19 people organized and met in private homes. The First Park Memorial Baptist Church on Garfield Street is the product of the 1982 consolidation of the First Baptist Church on State Street and the Park Memorial Baptist Church. This picture shows the beauty of the First Park Memorial Baptist Church, built in 1901. (Courtesy of Eleanor Seligman.)

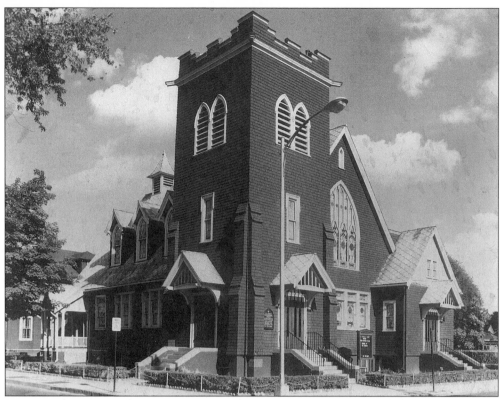

In November 1890, the congregations of Quincy Street Mission and Sandford Street Congregational Church united to become St. John's Congregational Church. This church, located on Hancock Street, was built in 1911 under the ministry of Dr. William DeBerry. The congregation emerged from the Free Church, or Zion Methodist Church (the first church for African-Americans), which in itself emerged from the Pynchon Street Society, an anti-slavery group that withdrew from the First Methodist Society. (Courtesy of Saint John's Congregational Church, United Church of Christ.)

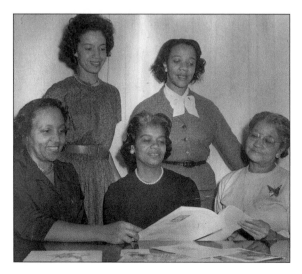

Pictured working on the history of St. John's in 1962 are, from left to right, as follows: (seated) Dr. Mary C. McLean, Dr. Martha K. Cobb, and Miss Naomi T. Cummings; (standing) Mrs. Sylvia C. Humphrey and Mrs. Dorothy J. Pryor. As the church grew, it helped to acclimatize the steady stream of black immigrants from the South at the turn of the 20th century. Rev. DeBerry began to develop institutional activities, including a Girls' and a Boys' Club, classes, and a parish home for working girls. (Courtesy of St. John's Congregational Church, United Church of Christ.)

Celebrating black history for a church event at St. John's, Ruth Bass Green and Anne E. Hatchett are seen wearing beautiful ethnic costume. (Courtesy of St. John's Congregational Church, United Church of Christ.)

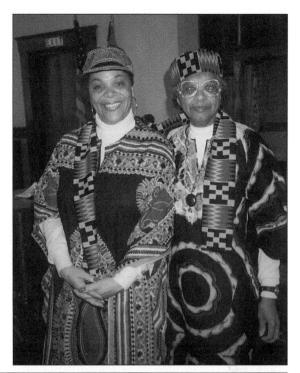

≈ Christmas Greetings ≈

FROM
Dr. and Mrs. Fred Winslow Adams

Pictured is the Trinity United Methodist Church of which the Pynchon Street Methodist Church was the mother church. The church split in the 1920s. Located in the Forest Park section, the sanctuary was dedicated on May 19, 1929. The church also includes the Grace Chapel, the Community building, and the Carillon Tower. Today, it serves a congregation of approximately 800 and is a community church, which opens its facility for use by all Springfield people. (Courtesy of Trinity United Methodist Church.)

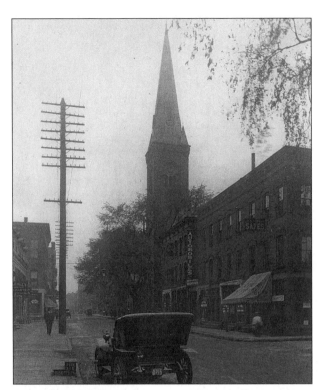

After Pynchon Street Methodist Church split, one half of the congregation went to Bliss Street Methodist and one half to the Bridge Street Methodist, which is shown here in the late 1880s. (Courtesy of Trinity United Methodist Church.)

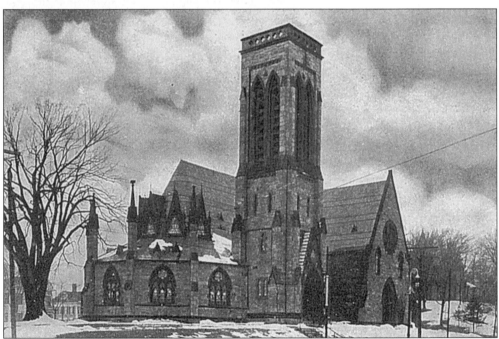

Union Memorial Church was erected at the foot of Round Hill, an exclusive residential area in Brightwood. The beautiful Gothic structure was built from local Monson granite in 1866, by a small evangelical congregation that hired Richard Upjohn for the project. (Courtesy of Victor Tondera.)

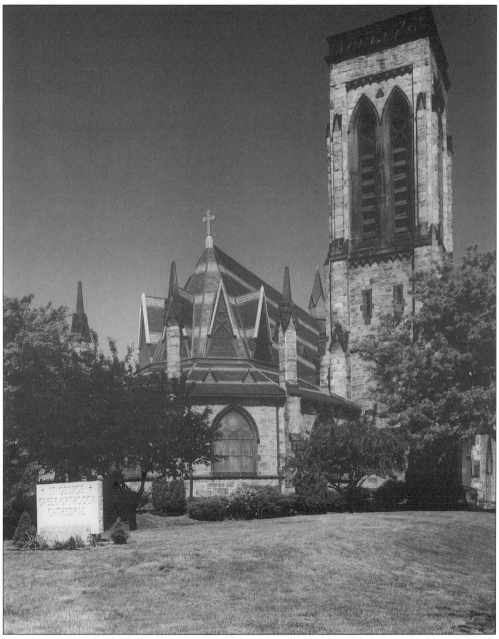

Now beautifully restored, Memorial Church was purchased by the Greek community in 1940. It was renamed St. George Greek Orthodox Memorial Church and was the third church of the congregation, which began in 1907 on Auburn Street. (Courtesy of Xenophon A. Beake.)

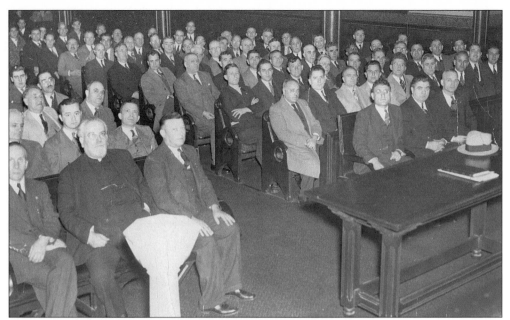

Shown inside the church that they had just purchased, the general assembly meets for the first time in 1940. Rev. Joseph Xanthopoulos is seated on the left in the front pew. Today, the church's proper name is Saint George Greek Orthodox Cathedral of Western Mass, and it continues to bring priceless Greek heritage and faith to the community.

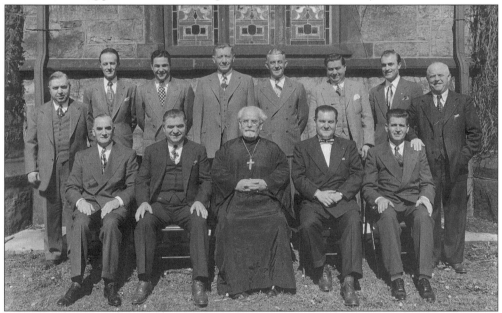

Since the founding of the Saint George Greek Orthodox Church in 1907, the church council has always been in charge of church affairs. This is a picture of the council in the early 1940s. From left to right are as follows: (front row) Louis Taloumis, James Xenakis, Father Joseph Xanthopoulos, Milton Eliopoulos, and George Cavros; (back row) George Katsoulis, Chris Kraverotis, Michael Pagos, Thomas Pappas, Christos Catjakis, Peter Valaoris, Theodore Thomas, and John Antonopoulas.

Pictured in 1924, the little Foster Memorial Church in Sixteen Acres housed a branch of the Hope Congregational Church of Springfield. A group of citizens took out papers as a parish organization on January 3, 1911, and when Cyrus Foster donated an acre of land, a building committee set to work. (Courtesy of Joyce Braithwaite.)

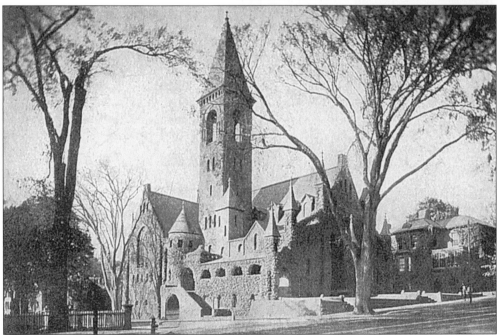

First Baptist Church began on May 13, 1811, and over the years, it has divided and united. First Baptist, shown here on State Street, eventually became an inner-city church and decided to join with Park Memorial Baptist to form one congregation of service and worship. (Courtesy of Victor Tondera.)

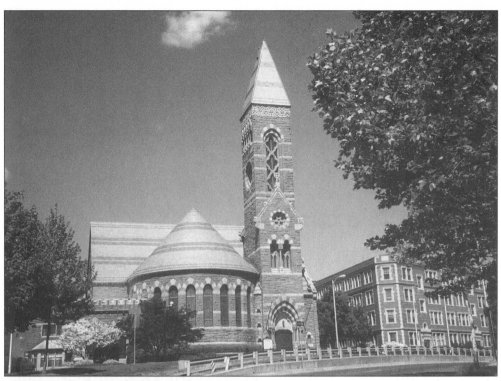

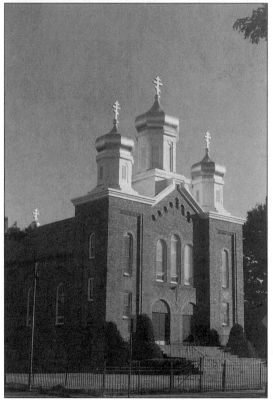

South Congregational Church was incorporated in 1842 as the Seventh Congregational Society of Springfield, with the Rev. Noah Porter as the first minister. Built of Longmeadow red sandstone, the church at the corner of Maple and High Streets was dedicated in 1875, and it still serves an active congregation today. (Courtesy of South Congregational Church.)

St. Peter and St. Paul Russian Orthodox Church was dedicated in 1944 on the site of the congregation's first church, which was a two-story brick house purchased in 1917 on Carew Street. In 1958, it was accepted into the Russian Orthodox Greek Catholic Church of America. It serves many people in the Russian community, many of whom are just arriving in the city now. (Courtesy of St. Peter and St. Paul Russian Orthodox Church.)

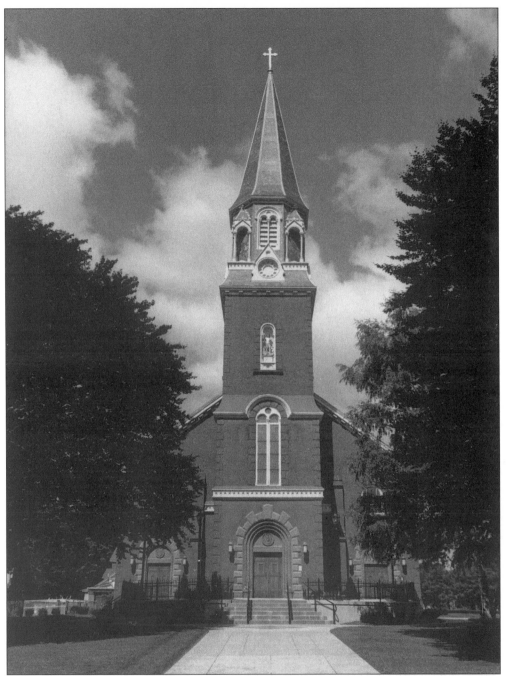

Catholicism began in Springfield in 1828 with Father James Fitton, who said mass in people's homes and at the town hall on State Street. In 1840, Rev. George Reardon was appointed to care for the Catholics of the city. He bought a house on Mulberry Street from George Dwight, moved it to a lot on Union Street, and on February 14, 1847, St. Benedict's Church began. In 1886, Rev. Michael Gallagher arrived, and he began purchasing five lots on State and Elliott Streets to build a new church. The first service in this grand church was held on Christmas Day of 1861. Nine years later, it would become St. Michael's Cathedral. (Courtesy of Fred LeBlanc.)

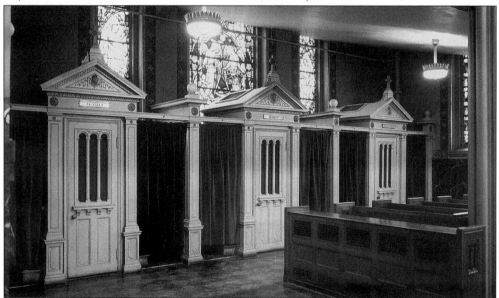

This baptismal record at St. Michael's Cathedral shows early-1865 dates of predominately Irish names. In 1870, when the church was selected as the seat of the new Roman Catholic Diocese of Western Massachusetts, it became a cathedral. It was the only church that was raised in the city between 1850 and the end of the Civil War. (Courtesy of Fred LeBlanc.)

Before renovations, these confessionals were located in St. Michael's Cathedral. Although all of Springfield joined in celebrating the consecration of the new church, it was an important step for the Irish community, who were now increasingly recognized as a legitimate part of the city and were contributing leadership to it. (Courtesy of the *Catholic Observer*.)

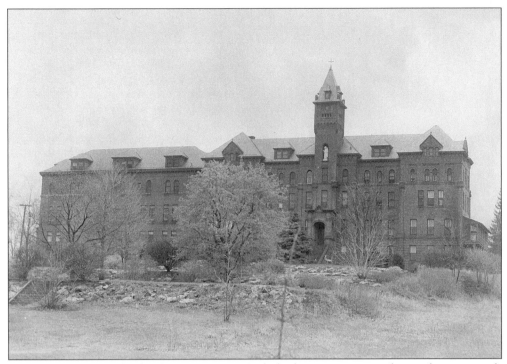

House of the Good Shepherd was a Roman Catholic home, set up as a haven for young girls who were considered "wayward." It later moved to a new building on Tinkham Road but eventually closed. (Courtesy of the *Catholic Observer*.)

Continuing its good work, the Catholic Diocese built St. Lukes Home for working girls on Spring Street, very near to the cathedral. Today, it serves the people of Springfield as a rest home. (Courtesy of Fred LeBlanc.)

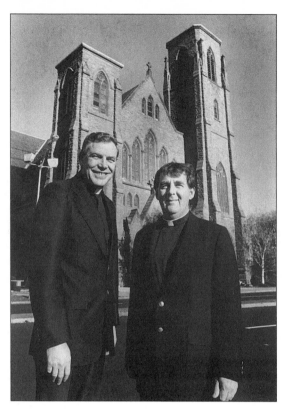

Sacred Heart Parish was formed in 1872 to meet the needs of the expanding Catholic population in the North End. Father James J. McDermott became the first pastor. The Sacred Heart School was built first, in 1877, and services were held there until the church was dedicated in June of 1874. Primarily Irish at the time, it is now a mixed ethnic congregation. Father Hugh Crean and Father George Farland, co-pastors in the late 1970s and 1980s, pose before the magnificent church building. (Courtesy of the *Catholic Observer*.)

As Sacred Heart Parish grew, the people at the "top of the hill " soon got their own congregation. On November 25, 1906, a new parish was formed, with Father Michael A. Griffin as the first pastor. The first church building for Our Lady of Hope was built in 1907, but it was replaced by this beautiful Italian Renaissance structure that opened on Christmas day in 1938. Our Lady of Hope School's first building was completed in 1923, and the second and current one was completed in 1964. (Courtesy of Our Lady of Hope Church.)

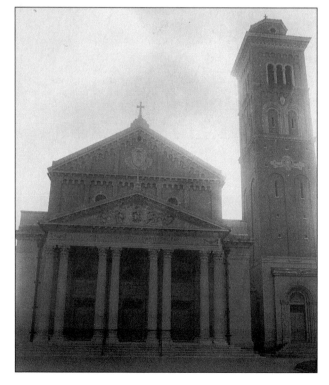

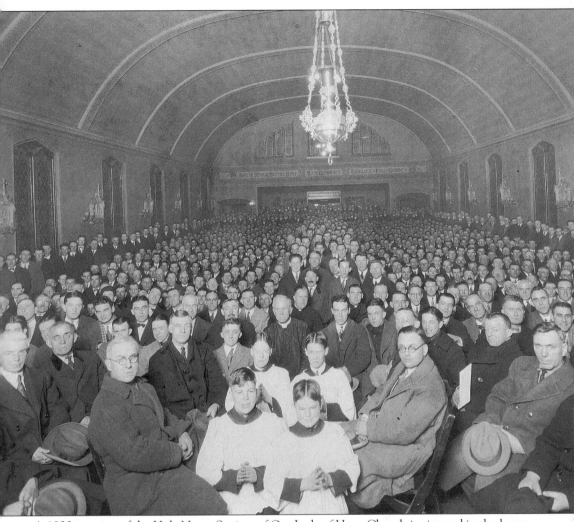

A 1923 meeting of the Holy Name Society of Our Lady of Hope Church is pictured in the lower part of the church building. An all-male society, it performed charitable work and was very popular, although it is no longer in existence today. (Courtesy of Our Lady of Hope Church.)

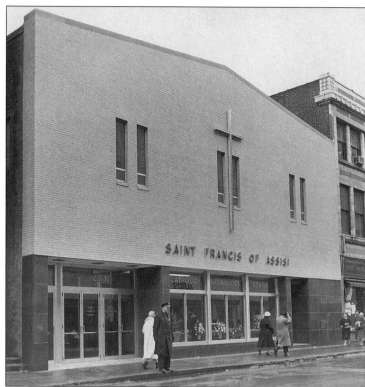

The Saint Francis of Assisi Chapel, located on Bridge Street, began in 1954 from a converted market. Not a parish church, it serves the people of the downtown area who drop in throughout the day. Four masses are said daily, and approximately 200 people pass through its doors on any given day. The chapel is staffed by Capuchin Franciscan Friars. (Courtesy of the *Catholic Observer*.)

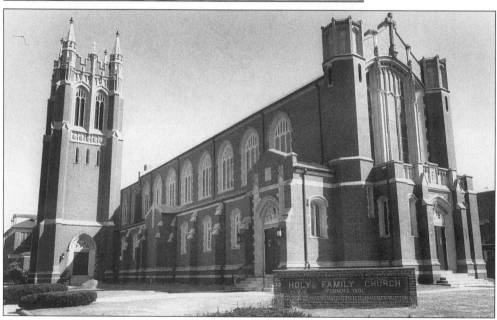

The congregation of Holy Family Church, a Gothic building on Eastern Avenue and King Street, started its community in 1901, and the church building was dedicated in 1907. Mostly Irish at the time, it grew with an Italian, African-American, and Spanish influx. Always serving the immigrant population, masses are now held in Spanish and English. (Courtesy of Fred LeBlanc.)

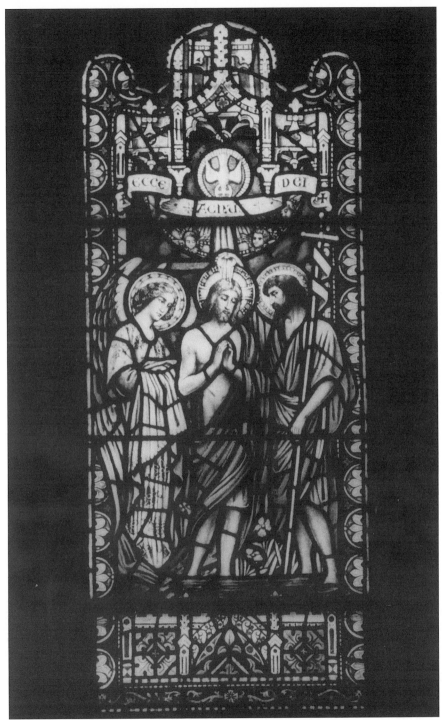

This beautiful view shows a well-crafted stained-glass window in the Gothic structure of the Holy Family Congregation. Besides being a blend of Irish, Italian, African-American, and Hispanic parishioners, it has now expanded to serve a small, but growing, Asian and Vietnamese population. (Courtesy of Fred LeBlanc.)

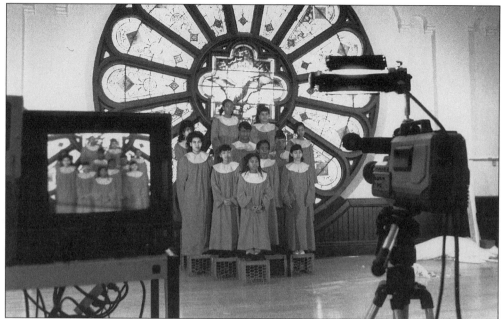

Members of the Friends of the Holy Family Junior Gospel Choir are shown, videotaping part of a documentary on famous African-American people at Chicopee City Hall. African-American churches in Springfield have always worked to bring the needs and issues of the population to the awareness of the entire city, while helping to develop solutions to social and economic problems. (Courtesy of Fred LeBlanc.)

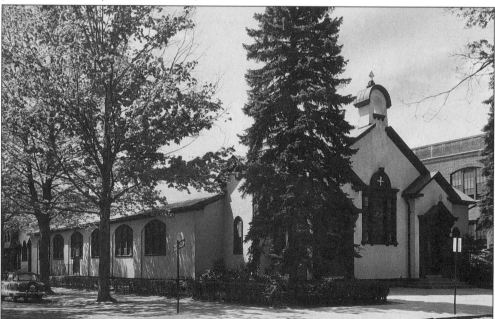

The Old Holy Name Church on Alderman Street was replaced by a newer church, located in the Forest Park neighborhood. Built for the growing Irish population in the early part of the 20th century, the parish began in 1909 and is still quite active, with a parochial school and social organization. (Courtesy of the *Catholic Observer*.)

St. Joseph's Church is located on Howard Street, in the South End. In March of 1873, a young missionary priest, Rev. Louis Guillaume Gagnier, founded a parish to serve the French-Canadian Catholics of Springfield. Serving mass in the auditorium of the city hall or at the home of parishioners, he helped secure a purchase of the land on Howard Street and the completion of the church by 1877. (Courtesy of St. Joseph's Church.)

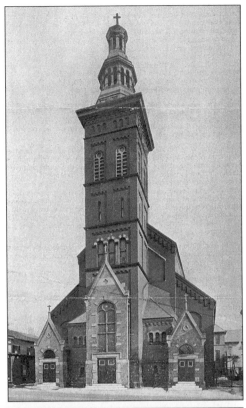

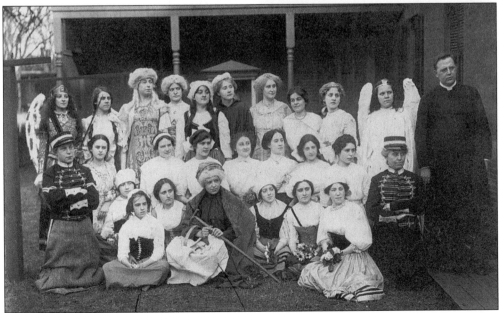

This group of children from St. Joseph's Church is posing after performing a pageant about Saint Joan of Arc. The picture dates from around 1915. Blanche Gagnon (front row, second from the left) is seen in the role of the young Joan, and Marie Ange Fagnon (fourth from the left, holding the staff) is in the role of the mother of Joan. (Courtesy of St. Joseph's Church.)

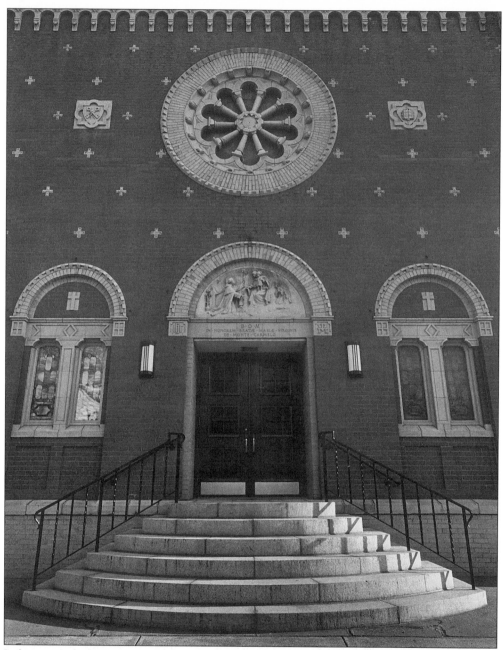

Italians, mostly from southern Italy, immigrated to Springfield as workers and skilled craftsmen. By 1893, there were more than 2,000 Italians living here. They first worshiped in the mortuary chapel of St. Michael's Cathedral, and in 1907, the first church that was founded exclusively for the Italian community was Our Lady of Mount Carmel Church. (Courtesy of Our Lady of Mount Carmel Church.)

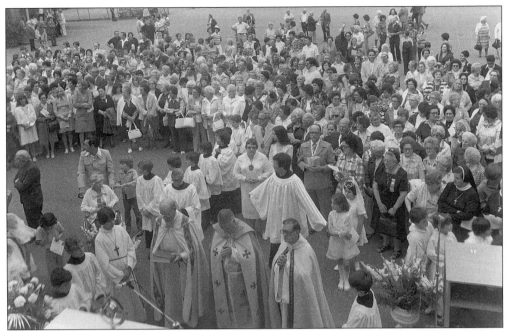

As with all ethnic parishes, Our Lady of Mount Carmel Church became a focus for the cultural and spiritual life of Italians in Springfield. The church is still 90% Italian today. Holding mass in the church's parking lot, the Stigmatine Fathers run the church on William's Street. (Courtesy of the Catholic Observer.)

The former convent of Our Lady of Mount Carmel Parish was once a South End firehouse, and the Daughters of Mercy, who used to run the Mount Carmel School, lived there. The school, still active, is now church run, and the convent is a preschool for the community. (Courtesy of Fred LeBlanc.)

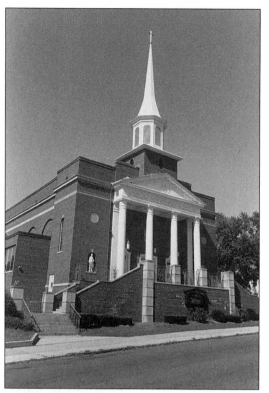

As the Polish settled in and grew around the North End, they soon needed a parish of their own. In July of 1917, Rev. Stanislaus Orlemanski was appointed pastor of Our Lady of the Rosary. A year later, the first church was dedicated, and a year after that, the parish school opened. The present church was dedicated in July of 1940. Four years later, Father Orlemanski made an historic trip to Moscow to speak with Joseph Stalin on behalf of the oppressed Polish people. (Courtesy of Fred LeBlanc.)

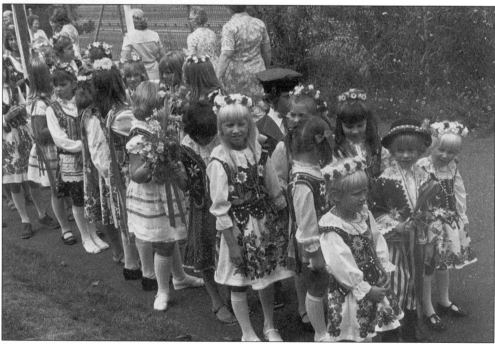

The children of Our Lady of the Rosary are shown, dressed in costume, participating in an ethnic celebration. The event was possibly Dozynki, in which the parish, as a whole, participates in a procession with the Dozynki wreath. (Courtesy of Fred LeBlanc.)

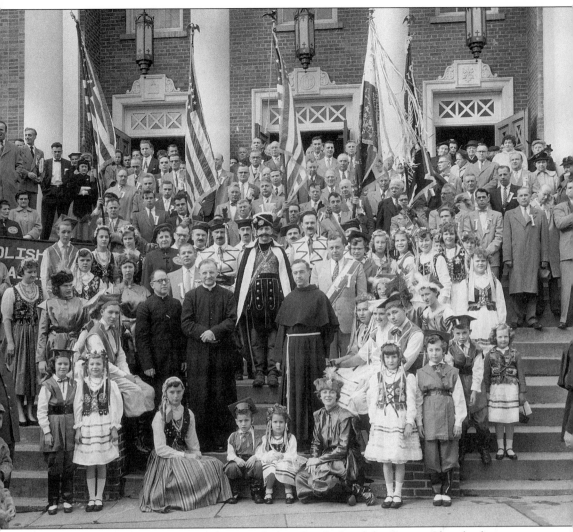

The entire congregation poses on the steps before Our Lady of the Rosary Church, during a celebration in the 1940s. As in the previous photograph, ethnic costume is worn by the children, men, and women. The parish has survived, despite the loss of church property for the construction of Route 291 and a fire in July of 1963, and it still remains strong and thriving. (Courtesy of Our Lady of Rosary Church.)

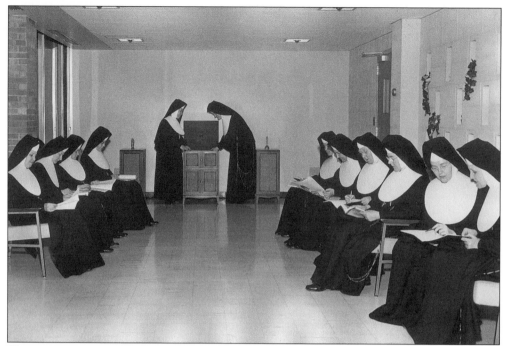

These nuns are pictured at the old Cathedral High School Convent in 1958. Shown in unknown order are Sister Particia Joseph, Sister Richard Francis, Sister Marie de Lourdes, Sister Mary Virginia, Sister Aloysius Maria, Sister James Francis, and Sister Helen Maria. (Courtesy of the *Catholic Observer*.)

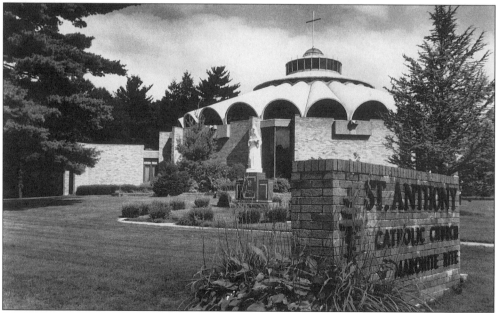

St. Anthony Catholic Church, Maronite Rite, was built as St. Peter and St. Paul's for the Lebanese population. As the immigration of various ethnic groups has increased during the 20th century, including the resettlement of Southeast Asian, Russian, and now Balkan refugees, the Catholic Church has responded to serve each new group. (Courtesy of Fred LeBlanc.)

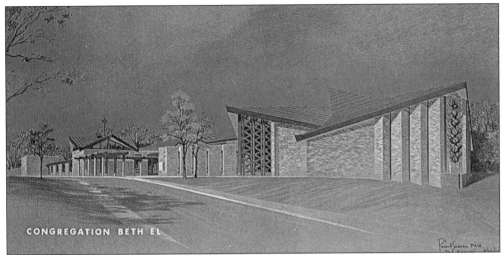

CONGREGATION BETH EL

In 1912, a group of Jewish men met to organize the first conservative synagogue in western Massachusetts, and in 1913, Congregation Beth El was organized. In 1918, a temple was dedicated at 150 Fort Pleasant Avenue. Due to growth, the congregation built a new temple on Dickinson Avenue in 1953, but that was destroyed by fire in October of 1965. People everywhere in the city of Springfield gave their support, and a new temple, pictured above, was dedicated on May 12, 1968. (Courtesy of Congregation Beth El.)

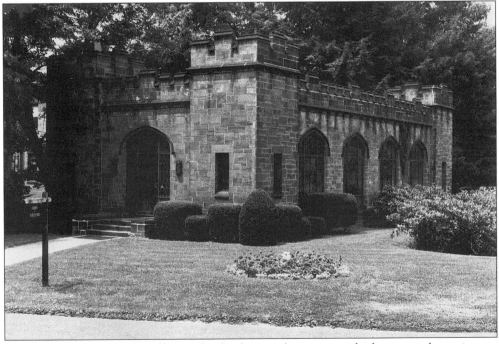

This 1932 structure is the office and columbarium (a room in which cremated remains are placed) of the Springfield Cemetery, which was opened in 1839. Inside its grounds are tombstones that date from as early as the 1600s. Civil War soldiers, some of who died in Springfield on their way home, are buried in a section named "Soldiers' Rest." The original town cemetery was in Court Square, but it was moved to make way for the railroad. (Courtesy of Douglas Goodhue.)

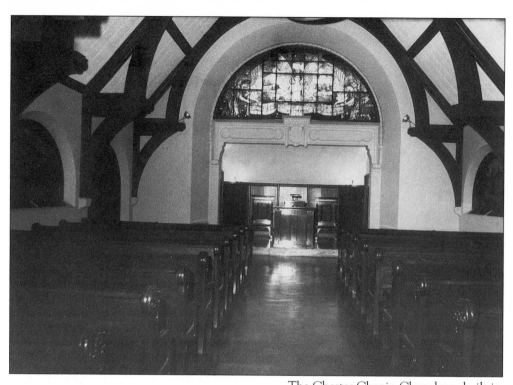

The Chester Chapin Chapel was built in 1895 on the Springfield Cemetery grounds. The chapel displays a beautiful Tiffany stained-glass window. Throughout the grounds are memorials, many of which are made of local granite and brownstone, honoring prominent early citizens. (Courtesy of Douglas Goodhue.)

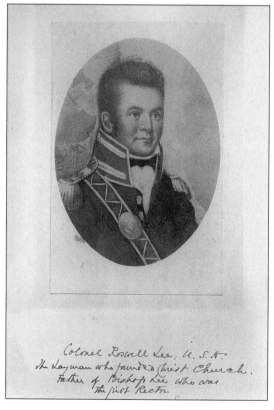

Colonel Roswell Lee, U. S. A.
the Layman who founded Christ Church.
Father of Bishop Lee who was
the first Rector

In 1816, Lieutenant Colonel Roswell Lee, the superintendent of the Federal Armory who is pictured here, requested permission from the Federal government to use an unoccupied building as a chapel. The first Episcopal chapel was dedicated in 1817 by the Reverend Titus Strong of Greenfield. (Courtesy of Christ Church Cathedral.)

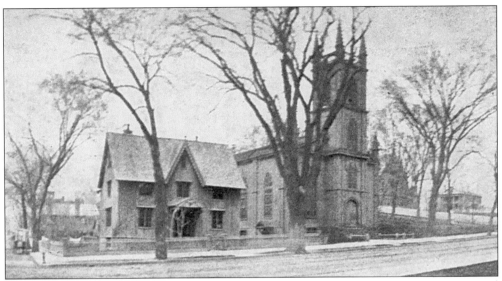

Twenty years after the dedication of the first Episcopal chapel in Springfield, the first Episcopal church, Christ Church, was built. Its first pastor was Rev. Henry Washington Lee, Colonel Roswell Lee's son. No longer standing, the Civic Center is now located at this site. (Courtesy of Christ Church Cathedral.)

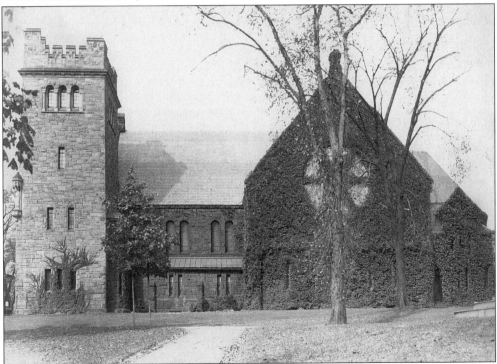

In 1876, the Episcopal congregation of Christ Church built their third church in the Norman style out of Longmeadow brownstone. Designed by Lord, Fuller and Wadlin of Boston in 1927, Christ Church became the Cathedral Church of the Diocese. Much was added to the church in this century, including an altar of Italian marble, a carved narthex screen, and a massive pulpit. (Courtesy of Christ Church Cathedral.)

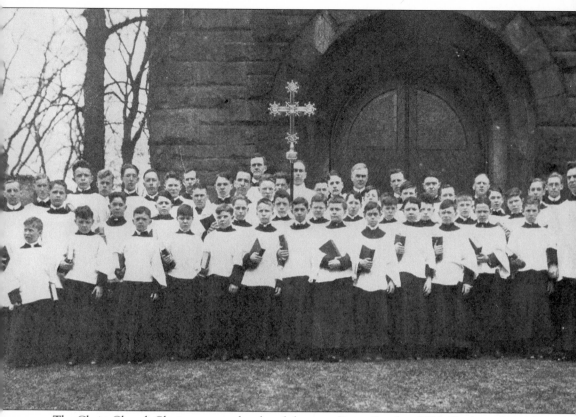

The Christ Church Choir poses on the church lawn on Easter Sunday, 1921. To the right in the photograph is the church organist and choirmaster from 1911 to 1923, Thomas Moxon. He was an Englishman who studied under Dr. Cuthbert Harris of London and at the London College for choristers. He was the first truly professional musician to occupy the post. (Courtesy of Christ Church Cathedral.)

Four

AN EDUCATION FOR ALL

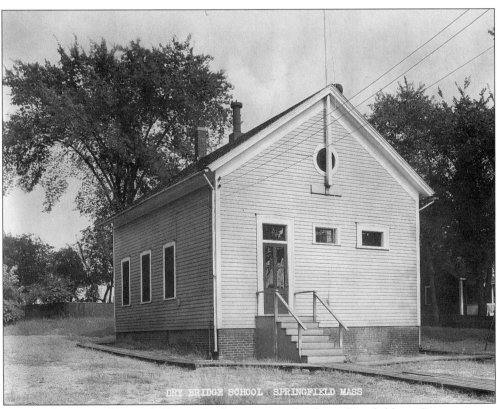

In 1653, the town of Springfield gave land to support schooling of its children. Over a century and a half later, after an 1812 private academy closed, Springfield appointed its first committee to investigate town schools, and this led to the organization of the first school committee, which was headed by William B. Calhoun, a Yale graduate. The Dry Bridge School, pictured here, was built in 1881, and closed in 1938. (Courtesy of Springfield School Department.)

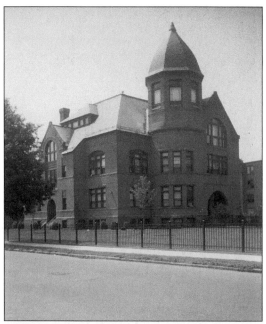

Tapley School was built in 1887, at the corner of Bay and Sherman Street to serve the growing population of the McKnight neighborhood. Additions were made in 1904, 1910, and 1954, and for a time, the first floor served as a normal training school. The building closed as a school in 1981 and has now been renovated as an apartment house. (Courtesy of the McKnight Homeowners Association.)

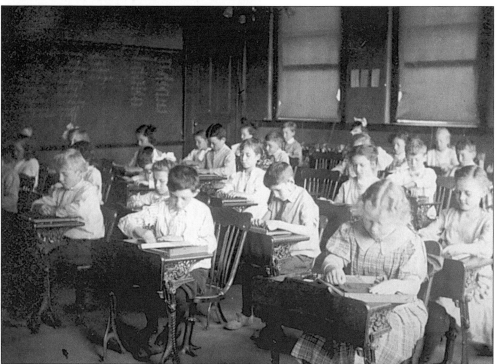

These children are pictured learning rug weaving in an Armory Street School classroom in the early 1900s. The school, which actually began as a one-room schoolhouse on the street, was built in 1902 by G. Wood Taylor, son-in-law of William McKnight. The first principal of the school, Anna Rice, allowed the neighborhood families to use the baths at the school. The school closed its doors at the end of the 1999 school year. (Courtesy of Springfield School Department.)

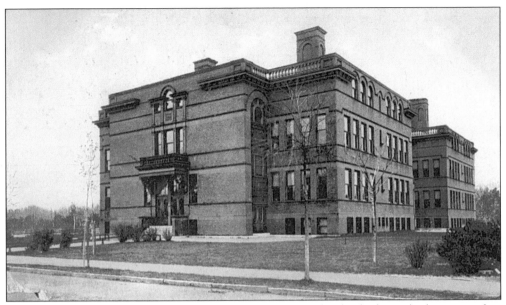

Architect B. Hammett Seabury designed the Forest Park School, which was built on top of an old cemetery in 1896. It began as a grammar school, but in 1917, it was changed to a junior high school. Additions were built in 1919 and 1936. In 1937, the Works Progress Administration (WPA) removed the entire third floor. The school remains open today. (Courtesy of Louis Cote.)

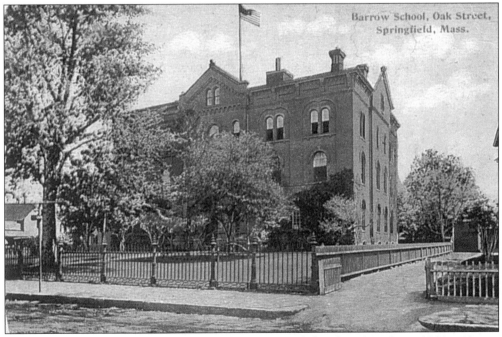

The Barrow School, on Oak Street, was built in 1892 and closed in 1944. Since 1866, a 12-year course of study was used in Springfield schools, thus approaching education as a continuous process from primary through high school. Also to the city's credit, Springfield was the first town in Massachusetts to appoint a superintendent of schools. (Courtesy of Victor Tondera.)

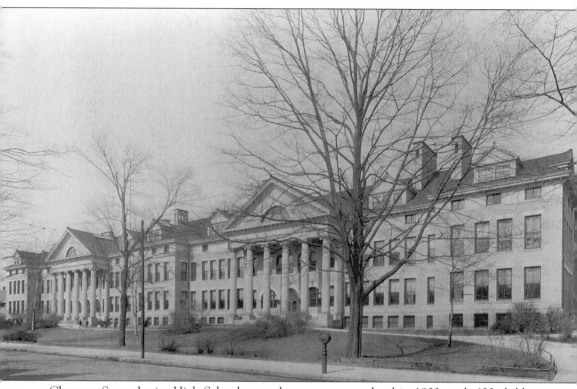

Chestnut Street Junior High School opened as a grammar school in 1903, with 600 children enrolled. In 1917, the superintendent of schools, James Van Sickle, established it as a junior high school, along with five other city schools. Chestnut built additions in 1908, 1919, and 1928. A clear demonstration of the city's immigrant population is that, during the 1930s and 1940s, Chestnut had children of 21 different ethnic groups within its walls. (Courtesy of Springfield School Department.)

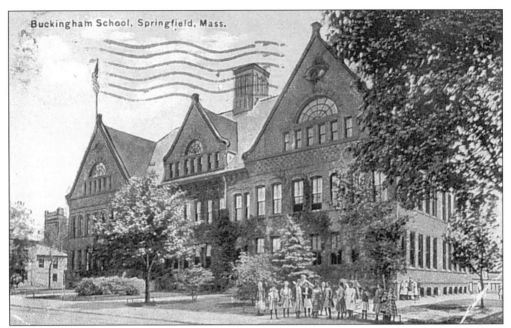

Buckingham School was built in 1891 on the corner of Eastern and Wilbraham Avenues. In keeping with Superintendent Van Sickle's plan, it too was designated a junior high school in 1917, and by 1922, it had become solely a junior high, with no lower grades in the building. The school closed in 1968. (Courtesy of Victor Tondera.)

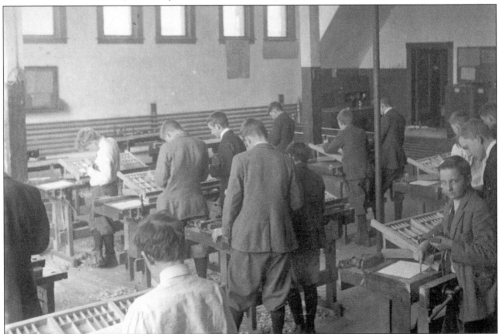

Extra-curricular activities were taught at all city schools to teach new skills. Demonstrating a forward-thinking attitude about equal opportunities, boys took knitting and weaving classes, as well as printing classes, as shown above at Buckingham School. (Courtesy of Springfield School Department.)

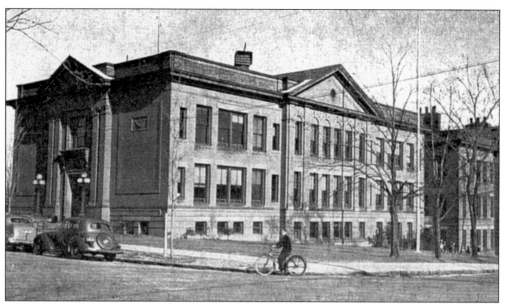

Education in the village of Indian Orchard began with the first public school, the Myrtle Street School, in 1848. As the population of children grew, a new school was required in 1854 and then a third in 1868, which is pictured here. The first female principal in Springfield, Rebecca Sheldon, served her position at the Myrtle Street School. Today, the building is used as elderly housing. (Courtesy of Karen D. Ledger.)

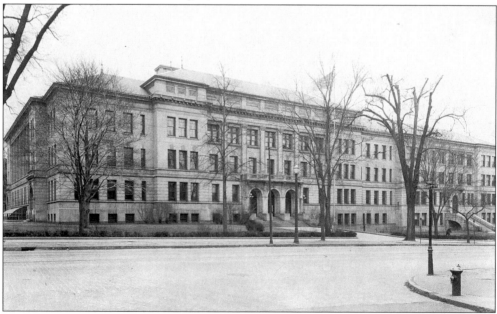

Classical High School was built in 1898 on State Street. It was originally called State Street High School, then Central High School in 1905, and it was renamed Classical in 1935. The school boasted seven levels, with an observatory tower on top. This was a high school that was geared for preparing students who were interested in a liberal arts education. Dr. Seuss was a graduate of Classical, which closed its doors in 1986. (Courtesy of Springfield School Department.)

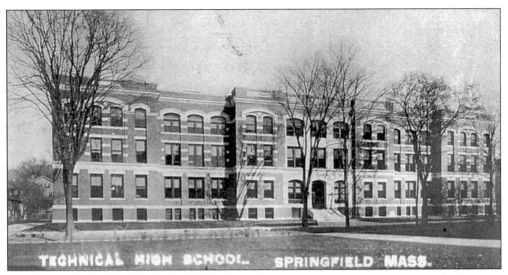

Technical High School, built in 1905 on Elliott Street, was initially called the Mechanic Arts High School. It has been an independent manual training school since 1898, when classes were held in a rented space at the Indian Motocycle Plant. The school's new name debuted with the new building. Declining enrollment forced the school to close its doors in 1986. (Courtesy of Victor Tondera.)

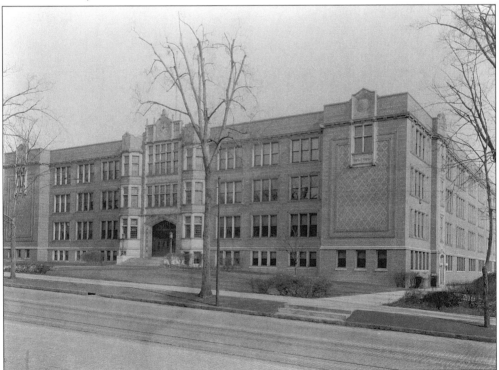

The city's third new high school, the High School of Commerce, was built on State Street in 1915. The land under the school once contained a pond and quicksand bogs. Renovated in 1977, the school has served thousands of Springfield students over 80 years. (Courtesy of Springfield School Department.)

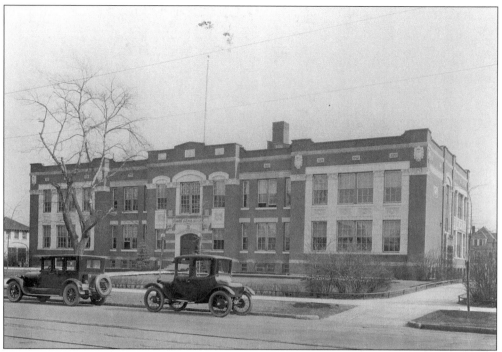

Summer Avenue School was built in 1912 at 45 Summer Avenue. It was constructed of Indian limestone by Daniel O'Shea, and the architects were E.C. and G.C. Gardner. The new school was built to relieve overcrowded conditions at the Belmont Avenue School. Additions were made in 1953 and 1998. In 1963, under Principal George W. Fisk Jr., a non-graded policy was started at the school, which meant that children moved to another level whenever the goals for the current level had been met. (Courtesy of Springfield School Department.)

The Sixteen Acres neighborhood started in 1651 from a royal land grant to farmers Thomas Rowland, John and Thomas Stebbing, and Francis Pepper, who each had a portion. This photograph, taken in September 1938, shows the small portable Sixteen Acres School after the hurricane of 1938. During the hurricane, 100-mile-per-hour winds, following many days of heavy rain, swept through the Connecticut Valley. (Courtesy of Joyce Braithwaite.)

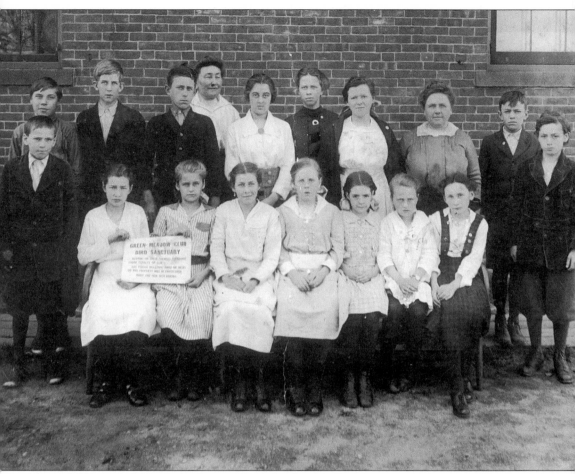

These children pose outside the Sixteen Acres brick schoolhouse, *c.* 1914. The two teachers in the back row are Inez Ingraham (fourth from the left) and Mary Coburn (third from the right). The children are holding a sign for the Green Meadow Club Bird Sanctuary. In 1914, Miss Coburn and Miss Ingraham started a bird hospital that cared for thousands of injured birds until it closed in 1933. (Courtesy of Joyce Braithwaite.)

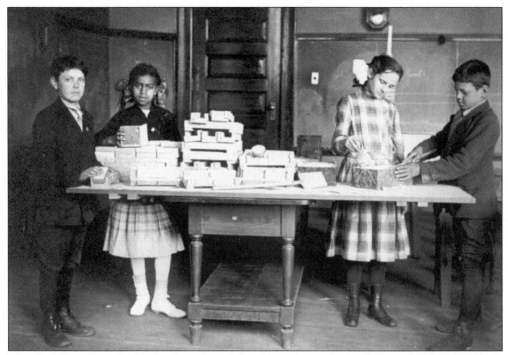

Fourth graders at Howard School are shown developing a project for their study of cement brick making. The bricks were later used by the students to build a colonial-style fireplace. Howard Street School was built in 1906, and in 1991, it was renamed Zanetti School. Like the Armory Street School, the principal allowed neighborhood families to use the showers inside the building after school hours. (Courtesy of Springfield School Department.)

A class of students from the Brightwood School is pictured in 1940. The school was first erected in 1874. The population of Brightwood grew quickly, and in 1898, B. Hammett Seabury designed the second Brightwood School. It was dedicated on March 1, 1899. An addition was made in 1916, and it still serves students today. (Courtesy of Enola Suffriti.)

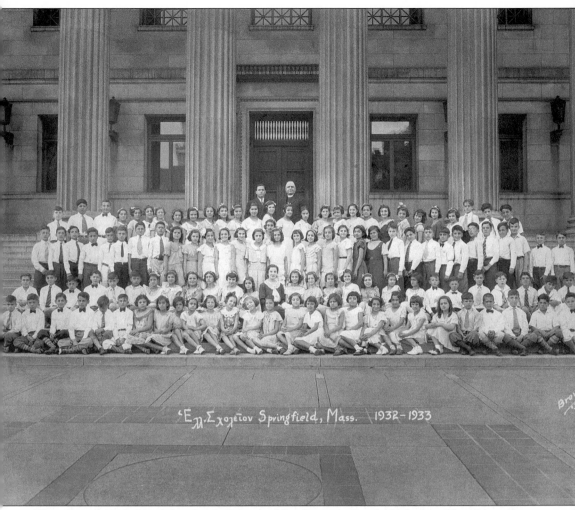

Ἑλ.Σχολεῖον Springfield, Mass. 1932-1933

The class of 1932–33 of the Greek School of St. George's Greek Orthodox Church poses in front of the Springfield City Hall. The school began in 1907, the same year that the Greek Orthodox Parish was started, to pass down the Greek language, customs, and celebrations from one generation to the next. The school remains very active with the congregation today.

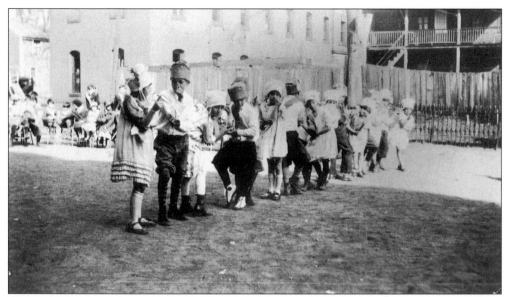

These children are playing in the backyard of the Howard Street School in the early 1900s. They are participating in a May Day celebration, complete with festive costumes. (Courtesy of James A. Langone.)

The Mount Carmel School began in 1948, and it was staffed and run by the Daughters of Mercy. This picture shows the very first grade one of the school. Seated in the front row, second from the left, is James Langone, owner of the photograph. Mr. Langone's mother is one of the students in the photograph above this one. (Courtesy of James A. Langone.)

Young children of Our Lady of Sacred Heart School are performing a song in the early 1970s. The school opened in 1948 to serve the parish, and like many parochial schools in Springfield, it was started by the Sisters of Saint Joseph. These women have contributed much to the intellectual development of city children over the years. (Courtesy of the *Catholic Observer*.)

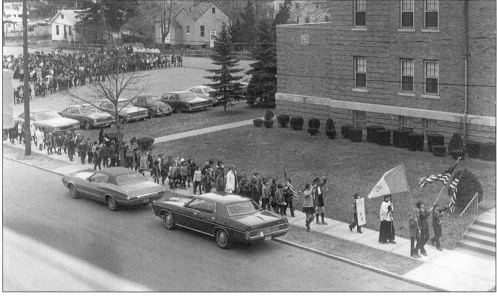

Our Lady of Sacred Heart School serves the parish and other children of the city's Pine Point neighborhood. It remains a kindergarten through eighth-grade school, serving over 350 students today. In 1963, when a new parish was formed in Sixteen Acres, many members of the Sacred Heart Parish, who had traveled from that neighborhood, chose to stay closer to home. This picture shows the school spirit of the 1970s. (Courtesy of the *Catholic Observer*.)

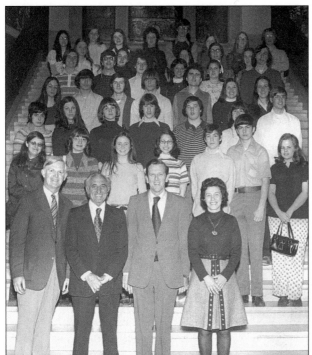

Cathedral High School is now the city's only parochial secondary school. Pictured here in the late 1960s, these high school students are on the steps of the State House in Boston. Members of a government class, they discussed issues facing the general court with legislative leaders. Pictured with the students are, from left to right, as follows: (front row) Mr. James Garvey; Representative Anthony M. Scibelli, chairman of the House Ways and Mean Committee; House Speaker David M. Bartley; and Mrs. Barbara Garvey, a teacher at the school, and Democratic State Committee member. (Courtesy of the *Catholic Observer*.)

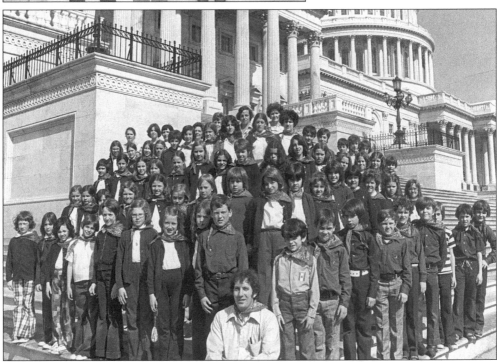

Children from the Holy Name School pose on the steps of the Capitol on a trip to Washington D.C. in the 1970s. The school was started when the parish began in 1909. The Sisters of Saint Joseph provided the first teachers for this school, which remains open and active today. (Courtesy of the *Catholic Observer*.)

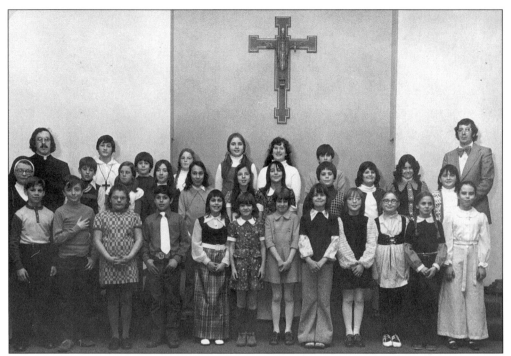

This 1970 picture shows children from the St. Thomas Aquinas School. The Sisters of Holy Cross arrived at this parish in 1919, and that September, the school opened with an enrollment of 177 children. In September of 1977, the school merged with St. Joseph's School to use their more spacious building. On December 8, 1978, fire totally destroyed the old St. Thomas Aquinas School building. Fortunately, there were no injuries. (Courtesy of the *Catholic Observer*.)

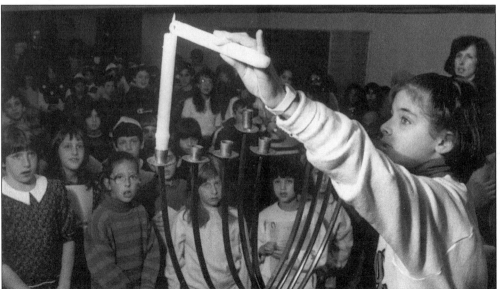

Young Jewish children can receive religious instruction at the United Hebrew School, which is an after-school program, located on Dickinson Street. Here they can learn the language, rituals, and customs of their community. (Courtesy of the Jewish Federation of Greater Springfield.)

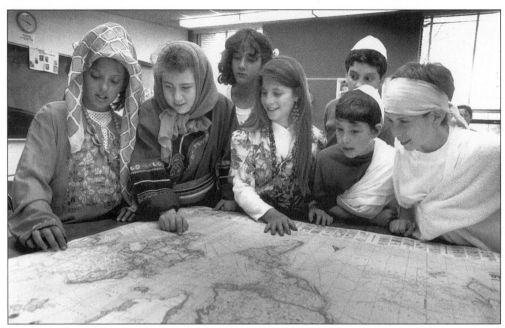

These children are learning geography while wearing historic attire. The Jewish Community Center Complex, built in 1954, serves as the cultural nucleus of the Jewish people in the area. Besides the school, the building houses the Jewish Federation of Greater Springfield, which serves as the umbrella agency for all Jewish organizations. (Courtesy of the Jewish Federation of Greater Springfield and Gail Shapiro.)

Yeshiva Academy, now located in Longmeadow, is a private day school that serves the Springfield Jewish community. At this establishment, children receive both secular and religious education. (Courtesy of the Jewish Federation of Greater Springfield.)

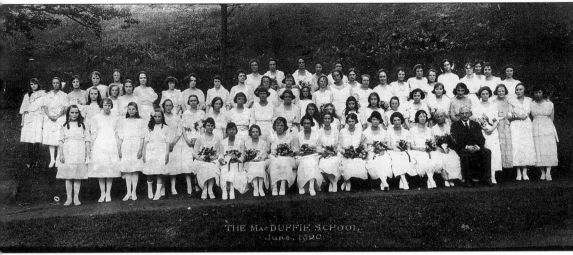

THE MacDUFFIE SCHOOL.
June, 1920

In 1890, John and Abby Parsons MacDuffie founded the MacDuffie School for Girls, after taking over the Misses Howard Family School for Girls. They established their school as a model of excellence in women's education. When John and Abby retired in 1936, they turned the school's leadership over to their son and daughter-in-law, Malcolm and Margaret. This 1920 picture shows the graduates of that year, seated and holding flowers. Mr. and Mrs. MacDuffie are seated on the right. (Courtesy of the MacDuffie School.)

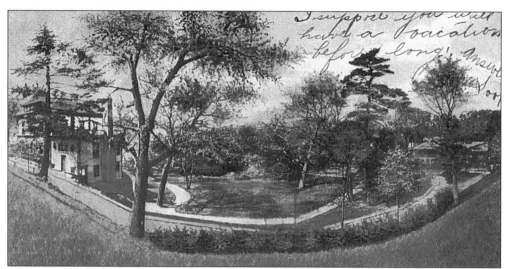

This is an early view of the MacDuffie School's grounds. During a 12-year period from 1956 to 1968, the school experienced tremendous growth, and it purchased the Wallace and Castle estates. Over the past 100 years, the school has educated more than 2,500 women and men (who were admitted after 1988), and it continues to be dedicated to academic excellence. (Courtesy of Louis Cote.)

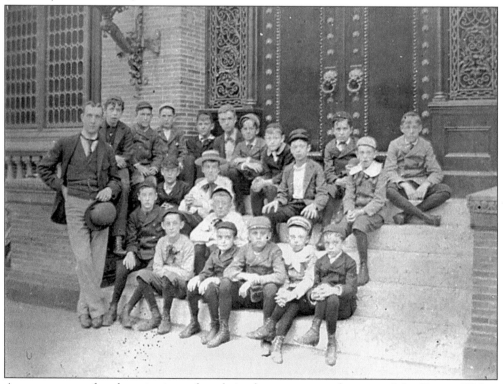

A young group of students is pictured, early in the century, on the steps of the George Walter Vincent Smith Art Museum, which had just opened in 1895. Many of the city's students benefited then, as they do now, from viewing and learning about the private collection of Mr. and Mrs. Smith. (Courtesy of Christ Church Cathedral.)

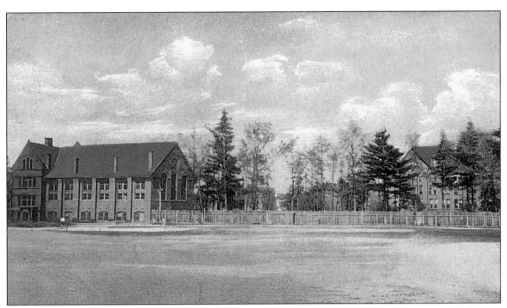

The Young Men's Christian Association Training School began in one building in Winchester Square. When it was founded, the school had never intended to charge for tuition, but a few years later, when the campus moved to its present location, tuition fees were introduced. (Courtesy of Louis Cote.)

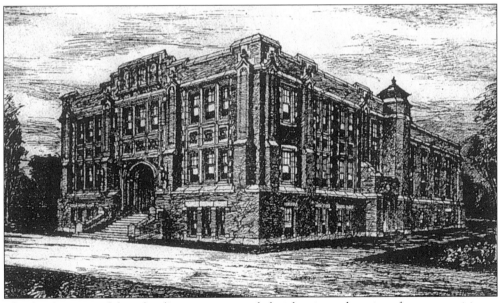

The development of the school's campus proceeded with private donations from many citizens, in particular Julius Appleton, Horace Smith, and Henry S. Lee. Ironically, the Appleton family was one of the college's most generous supporters, but they could not be considered corporators or trustees of the school because of their Unitarianism. (Courtesy of Springfield College.)

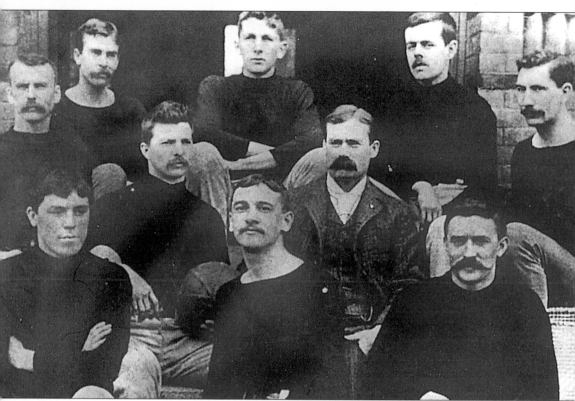

Dr. James A. Naismith, while looking for some form of activity to keep students in good athletic condition between the football and baseball seasons, developed basketball. The Basketball Hall of Fame, located in Springfield, is in honor of this part-time instructor at the YMCA Training School, now Springfield College. (Courtesy of Springfield College.)

Founded in 1885 in Lowell, Massachusetts, the American International College was originally called "The French-Protestant College" by its founder, the Reverend Calvin E. Amaron. The college moved to its present location when Springfield offered financial assistance, and a site, during the 1890s. The college provided an education for many immigrants who were arriving in the United States from diverse countries. To reflect this, the name of the school was changed in 1905 from the French-American College (its name since 1894) to American International College. In this picture, students are shown outside of Adams Hall. (Courtesy of American International College.)

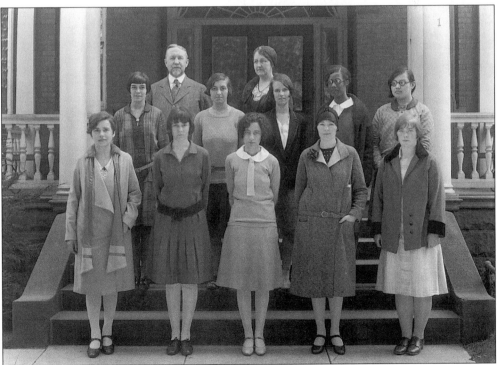

Posing in 1928 on the steps of Lee Hall at American International College, President Chester Stowe McGown (1911–1946) is seen with a racially diverse group of co-eds. (Courtesy of American International College.)

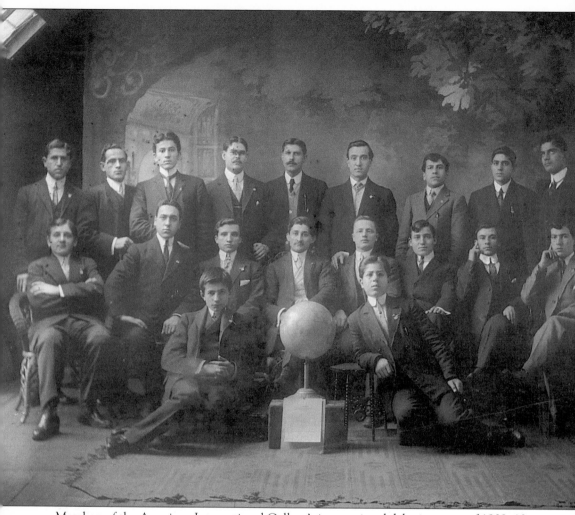

Members of the American International College's international debating team of 1909–10 strike a studious pose for their formal yearbook picture. At the turn of the 20th century, the college continuously sought to train recent immigrants for citizenship in the United States. The college's students went on to become effective community members and citizens. (Courtesy of American International College.)

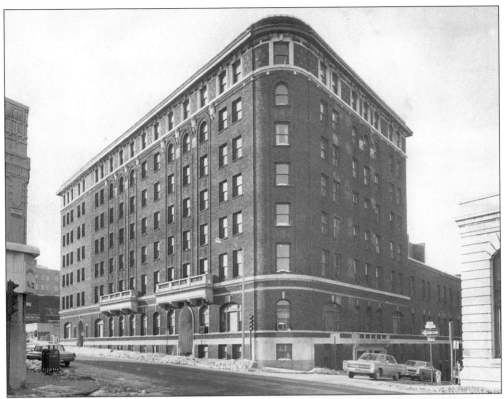

Western New England College began, in 1919, as a division of Northeastern College, and it was then called Springfield-Northeastern College. Classes were held in the YMCA building at 114 Chestnut Street, which is shown in this 1955 photograph. To the right in the picture, the corner of the Kimball Towers Hotel can be seen. (Courtesy of Western New England College.)

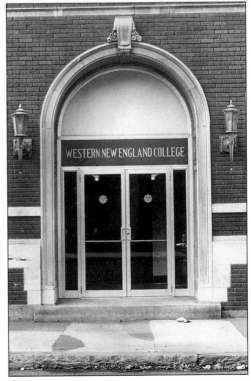

This view of the college building shows the entrance on Chestnut Street. In 1951, when Northeastern College decided to end its school in Springfield, a charter was taken out, and Western New England College began. By 1956, 131 acres were purchased on Wilbraham Road, and the first building was erected there in 1959. The college now has over 28,000 alumni worldwide. (Courtesy of Western New England College.)

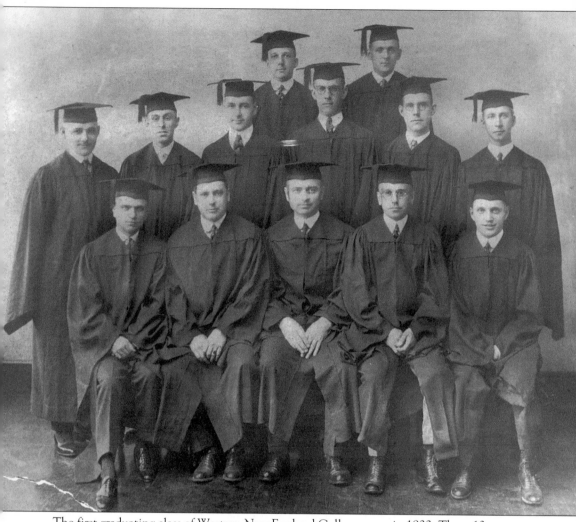

The first graduating class of Western New England College poses in 1922. These 13 young men completed their college courses during the evenings and graduated with Bachelor of Commercial Science degrees. Five years later, the school graduated its first seven law students. (Courtesy of Western New England College.)

Five

SERVING THE PEOPLE

Looking like a very capable and industrious bunch, the Springfield newsboys pose for a group picture. In 1824, Samuel Bowles Sr. founded the *Springfield Republican*, and in 1844, it became the first Massachusetts daily newspaper outside of Boston. The city soon gained two more newspapers with the founding of the *Springfield Union* and the *Springfield Daily News*. (Courtesy of James A. Langone.)

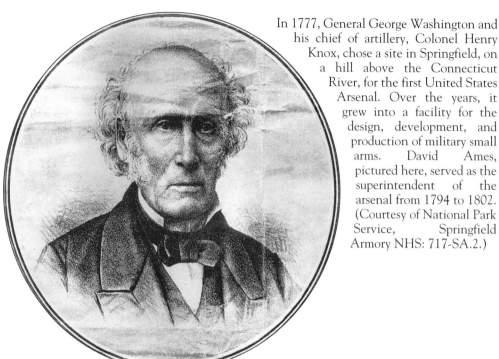

In 1777, General George Washington and his chief of artillery, Colonel Henry Knox, chose a site in Springfield, on a hill above the Connecticut River, for the first United States Arsenal. Over the years, it grew into a facility for the design, development, and production of military small arms. David Ames, pictured here, served as the superintendent of the arsenal from 1794 to 1802. (Courtesy of National Park Service, Springfield Armory NHS: 717-SA.2.)

In 1794, the federal government decided to manufacture its own muskets so as not to be dependent on foreign arms. President George Washington again chose Springfield as a site for one of two federal armories, the other being Harper's Ferry. Major J.W. Ripley served as superintendent from 1840 to 1854. In order to prevent vandalism on the grounds, he ordered the present fence to be built from melted-down Revolutionary War canons. (Courtesy of National Park Service, Springfield Armory NHS: 5583-SA.1.)

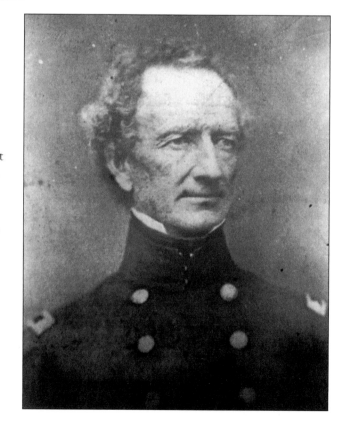

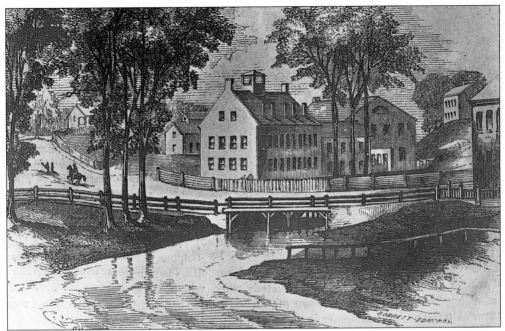

Approximately one mile from the Armory Hill Shops (now the location of the National Historic Site) was the Water Shops, on Mill River, where much of the heavy manufacturing was carried out with the assistance of water power. In the 1800s, wood stocks were made from black walnut at the Water Shops, using the ingenious lathe that was invented by Thomas Blanchard. This lathe revolutionized technology by enabling any worker to easily turn out identical irregular shapes. (Courtesy of National Park Service, Springfield Armory NHS: X1325-SA.3.)

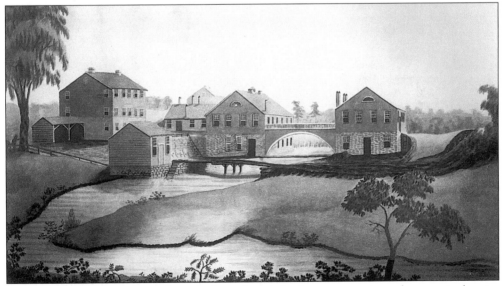

Originally, there were three shops built to house the heavy operations that required water power. But in 1857, the Lower and Middle Water Shops were sold, and activity was concentrated in the Upper Water Shops, which is the location of the Water Shops Complex today. (Courtesy of National Park Service, Springfield Armory NHS: X1324-SA.1.)

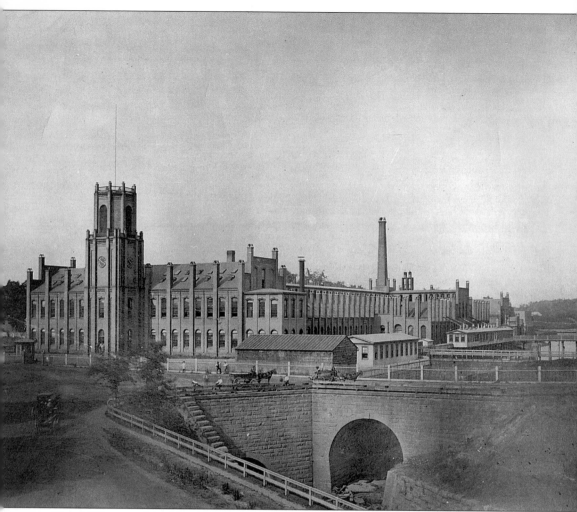

This 1905 view of the Upper Water Shops shows the expansion that took place in 1902, from the original shops that were built in 1857. After the start of the Civil War, Colonel Ripley, once the armory superintendent and now the chief of ordinance for the War Department, demanded expansion of production at the site. In just a few years, the work force grew from 200 to over 2,600 men. (Courtesy of the National Park Service, Springfield Armory NHS: temp-069.)

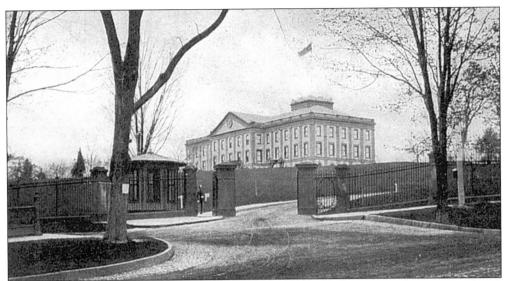

This early view of the arsenal from the south gate, off of Pearl Street, gives a feel for the imposing nature of the structure. The building was erected in 1847, and it is now preserved as a national park and museum. (Courtesy of Victor Tondera.)

This photograph shows the rear of the main arsenal building. The first percussion rifles were produced at the Springfield Armory in 1855. These rifles were used in every battle of the Civil War and by the Sioux Indians to defeat General George A. Custer at the Battle of Little Big Horn in 1876. Production of these weapons was completed in 1865. (Courtesy of Larry Gormally.)

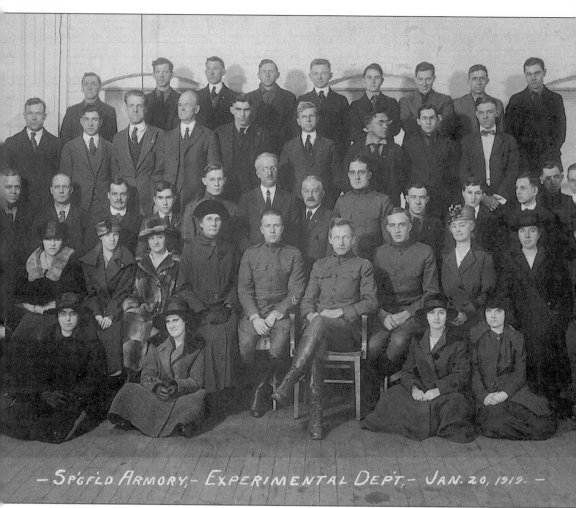

- SP'GFLD ARMORY,- EXPERIMENTAL DEP'T,- JAN. 20, 1919. -

The armory's Experimental Department sits for the camera on January 20, 1919. In the 1890s, the armory became the Army's main laboratory for the development and testing of new small arms. It was in 1919 that John Garrand, a gun designer, first came to work here. (Courtesy of National Park Service, Springfield Armory NHS: temp-684.1.)

John C. Garrand poses with the M-1 rifle, on
June 19, 1945. After beginning work to
develop a semi-automatic rifle, he submitted
many designs over a period of five years, and
finally, in 1924, the Army approved one for
further testing. This was the M-1 rifle, which
the Army adopted in 1936, and in 1940, the
Marine Corps followed suit. Over 4.5 million
copies of the M-1 were made at the armory.
(Courtesy of National Park Service,
Springfield Armory NHS: 1943-SA.a.1.)

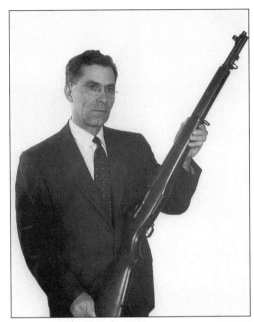

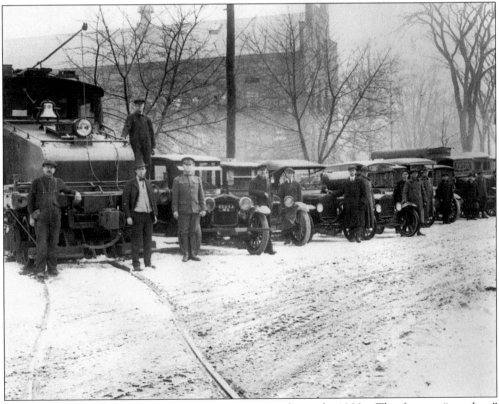

These men are arriving for work at the armory in the early 1900s. The famous "trapdoor"
Springfield Rifle, the model 1903, was another weapon that was made here. Used in World War
I, it is still considered one of the most accurate rifles ever made. (Courtesy of National Park
Service, Springfield Armory NHS: 144NHS.6.1.)

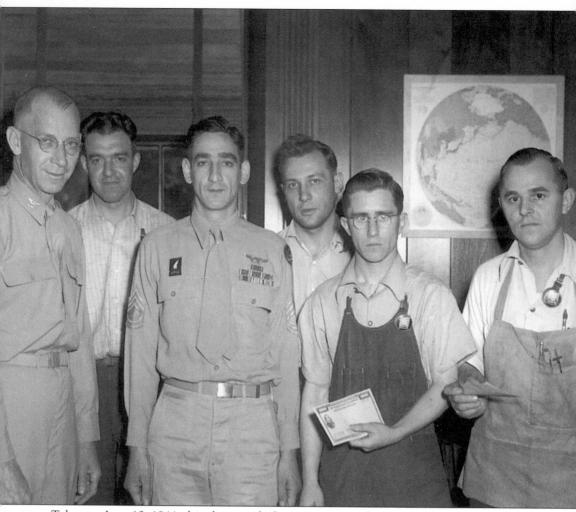

Taken on June 12, 1944, this photograph shows armory employees participating in a war bond drive. Colonel George Woody and Tech. Sergeant Michael Arnoth stand with civilian workers. Patriotism was the norm at the Springfield Armory. (Courtesy of National Park Service, Springfield Armory NHS: 4551-SA.1.)

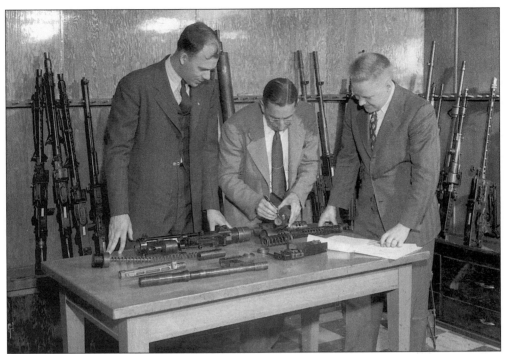

Armory officials are shown working in the weapons inspection room at the Springfield site. The national defense needs of World War II brought renewed vitality to the armory and the entire city, and once again, the armory expanded. This time, the number of workers grew from 1,000 to 7,000 workers. Westinghouse, American Bosch, and Indian Motocycle were among the city plants for which employment increased as a result of the demand for war-related products and parts. (Courtesy of National Park Service, Springfield Armory NHS: 6009-SA.1.)

Lieutenant Colonel Charles Zumwalt served as the final superintendent of the Springfield Armory from 1967 to 1968, when it was closed by a controversial economy measure of the Defense Department. In 1967, the Springfield Technical Community College opened on the grounds of the armory. The college supplied the city with a skilled and well-trained labor force by linking business and industry with college programs. (Courtesy of National Park Service, Springfield Armory NHS: 1067.66.a.1.)

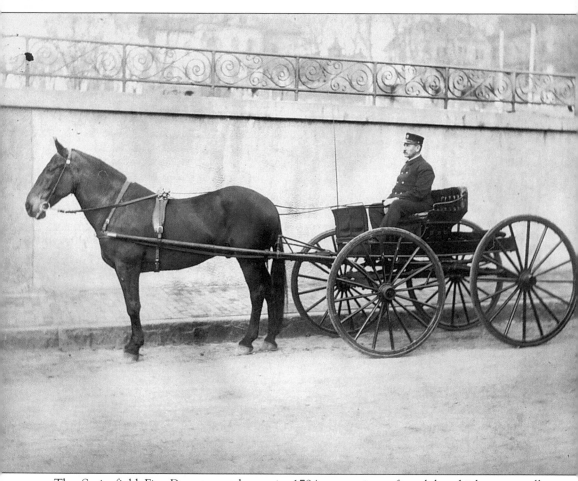

The Springfield Fire Department began in 1794 as a private fire club, which was totally volunteer-run until after the Civil War. The department's first chief was 72-year-old Elijah Blake. This photograph is of Warren Littlefield, chief engineer, as he parks in front of the railroad station on Lyman Street. He always drove himself to city fires. (Courtesy of Springfield Fire Department.)

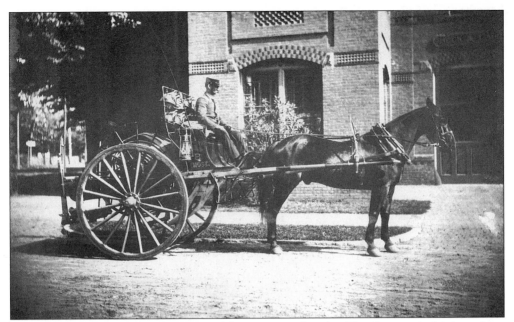

Different pieces of equipment were used for very specific jobs. This fireman is driving a hose wagon. Before the current system, hoses were hooked into wooden underground pipes that were opened up with an ax and then "fireplugged" to close them. Water was also drafted from ponds or any ready source. (Courtesy of Larry Gormally.)

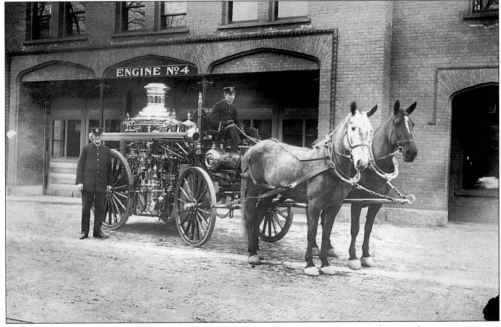

A steamer wagon, pictured here in 1904, could often be seen rushing to fires with steam pouring out of the top. The city purchased its first steam-pumping fire engine in 1862, for which the problem of a water supply still had to be faced. After a fire in July of 1864 destroyed Haynes Music Hall because the water ran out, the chief engineer reported that Springfield was virtually defenseless against major fires. (Courtesy of Springfield Fire Department.)

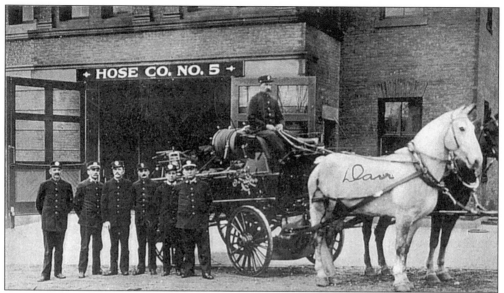

The men of the Indian Orchard Hose Company no. 5 proudly display their truck in front of the station. Besides the water shortage problem in the 1860s, the city also discovered that its old wooden pipes were rotted and leaking. The time had come to do something about the situation. (Courtesy of Karen D. Ledger.)

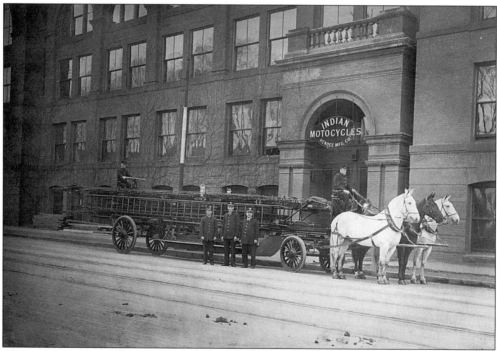

Shown here in front of the Indian Motocycle plant in Winchester Square are Springfield firemen with their ladder truck, which was pulled by three horses. The ladder's full extension was 100 feet, and when it was being used, the hose would extend up with the ladder. The steamer trucks kept the water boiling, so that the steam could force the water through the hose. (Courtesy of the Springfield Fire Department.)

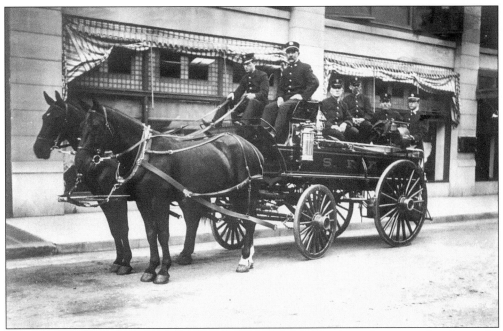

By 1860, when this picture was taken, the water solution for fire safety seemed to be in the hands of the Springfield Aqueduct Company. A contract was signed with them, in 1865, to build a 40-million-gallon reservoir at Van Horn Park and to lay new pipes downtown. The company also agreed to supply the city with water for 10 years. (Courtesy of John Sampson.)

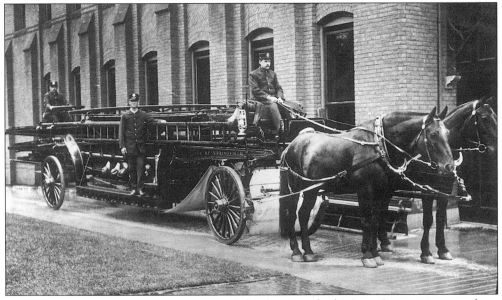

In 1872, the new city government created the first Board of Water Commissioners, whose purpose was to direct and finance the construction of a water system. The commissioners caused a city-wide feud when they favored a plan depending not on the river, but on a rural watershed in Blandford. Eventually, construction began on the Little River Water System, and after five years and the employment of 5,000 laborers, the fire department and the entire city had their new and permanent water supply. (Courtesy of James A. Langone.)

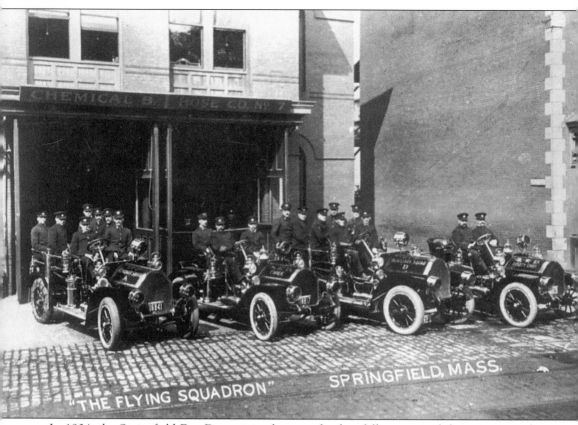

In 1904, the Springfield Fire Department became the first fully motorized department in the country. The department was outfitted with Knox vehicles, which were manufactured in the city. Self-named "The Flying Squadron," these firemen proudly show off their new equipment at the Winchester Square station. (Courtesy of John Sampson.)

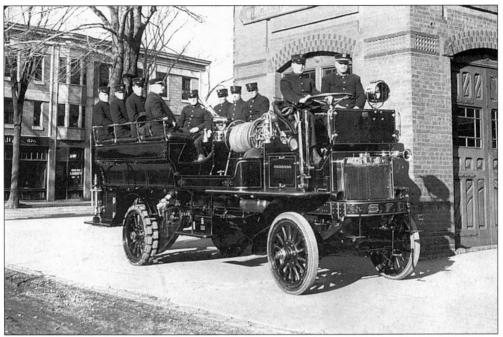

Adapting to the new equipment, driver Percy Osborne sits at the wheel of a triple-combination Knox. The engine was chain driven, and the body of the vehicle rested on solid rubber tires. Conveniently, the Knox plant was located just across the street from the Winchester Square station, which meant that repairs and needed parts were easily dealt with. (Courtesy of Springfield Fire Department.)

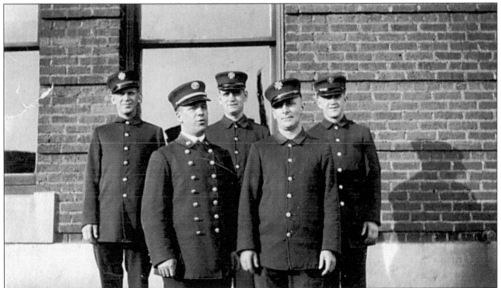

The fireman pictured second from the left is recognizable as an officer because of his double row of buttons. The men also wore emblems on their hats that indicated what type of company they were assigned to, whether it was a hose or ladder company, for example. In this 1934 photograph are, from left to right, Walter Baird, Lt. Roberts, Frank Darby, Vic Parsons, and Ernie Ruhe. (Courtesy of Springfield Fire Department.)

At first, there was only one constable in Springfield for law enforcement. Elizur Holyoke, being one of the first, was appointed to the position in 1651. Of course, as the plantation grew into a town, and the town into a city, the police force also grew. This 1960s view is of the old police station on Columbus Avenue. This building is no longer in use, as the department moved to new headquarters on Pearl Street in 1968. (Courtesy of Springfield Police Department.)

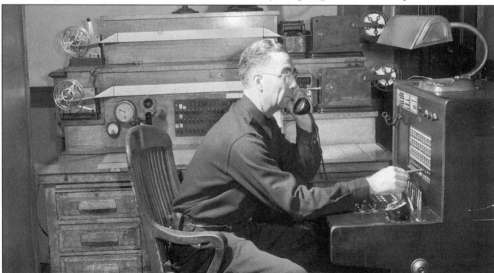

Officer Peter Brady, pictured in 1940, is at the switchboard of the Columbus Avenue station. He is using the Gamewell System of police signals, which connected the department to police boxes throughout the city. These boxes were the only link that policeman had to the station if they needed backup. (Courtesy of Springfield Police Department.)

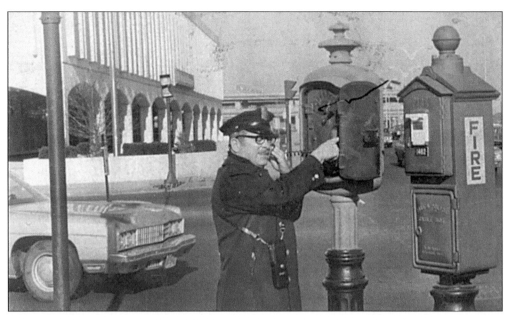

Officer Frank Calvanese was appointed to the department in 1951, and he retired in 1982. He is shown working his beat and calling into the station on the Gamewell Box. (Courtesy of Springfield Police Department.)

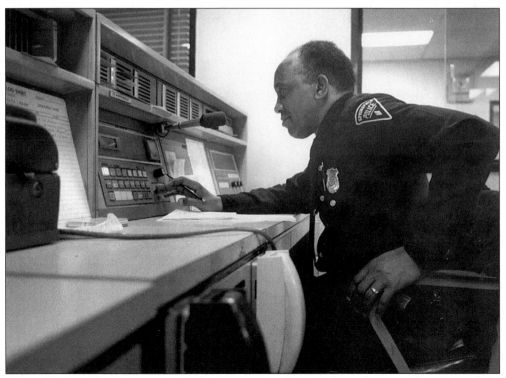

Officer Herbert Henderson is pictured, c. 1970, using the new dispatch system that replaced the Gamewell. This new system meant that police officers could keep in touch with headquarters by radios in their cruisers. (Courtesy of Springfield Police Department.)

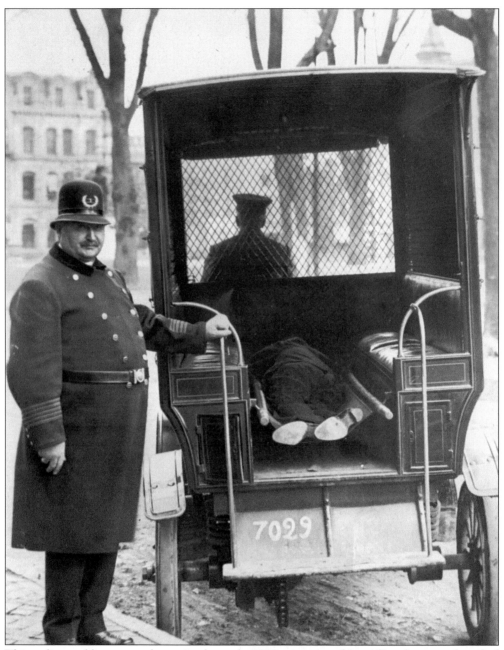

This police paddy wagon, shown in the early 1900s, is set to drive off with an unidentified citizen. This is likely to have been one of the first motor-driven police wagons by Knox. The vehicle seated ten people, had a two-cylinder horizontal chain-driven motor, and cost $2,800. (Courtesy of Springfield Police Department.)

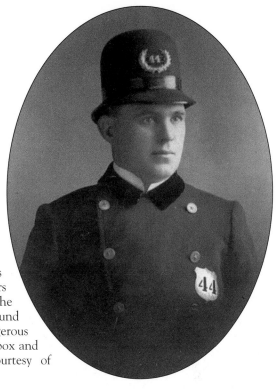

These watchmen were photographed in the late 1800s wearing the badges that indicated their departments. In those days, while on duty, the night and day watchmen were isolated from the stations, except for the call boxes. Very often, watchmen who worked the bar areas of the city would hire a "runner." Runners were bar regulars who were given a key to the police call box, and if the watchman found himself outnumbered or in a dangerous situation, the runner would sprint to the box and call into the station for backup. (Courtesy of Springfield Police Department.)

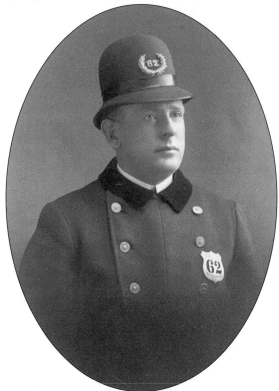

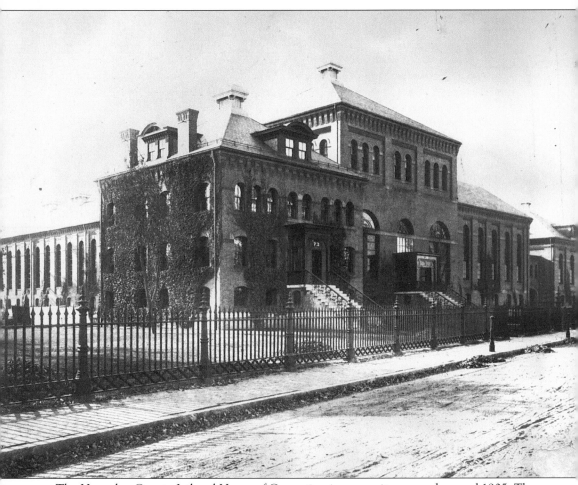

The Hampden County Jail and House of Correction is seen as it appeared around 1905. The sheriff and his family lived in the house attached (on the left) to the main building, as was the custom then. The last legal hanging in Massachusetts took place here on December 30, 1898, when Dominick Krathofski was executed for the murder of his step-daughter, Victoria Pinkos. (Courtesy of Larry Gormally.)

Oscar Luthgren, pictured here, was one of many Springfield men sent to France in World War I as an infantryman, or doughboy. Although it is common knowledge that women worked in the factories during World War II, it is not widely known that they did the same in World War I. The Springfield Armory employed many women during those years, in order to keep weapon production up.

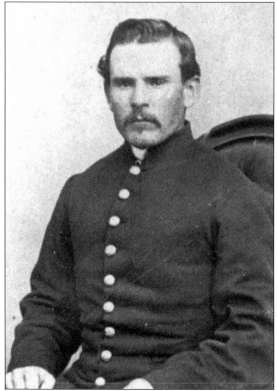

A young Springfield soldier poses in his uniform before leaving for the Civil War. The complex situation of dealing with the need for troops in the Army deeply touched the community. In the beginning years of the war, enough soldiers enlisted out of enthusiasm for the cause, and 40,000 Massachusetts men joined 32 volunteer regiments.

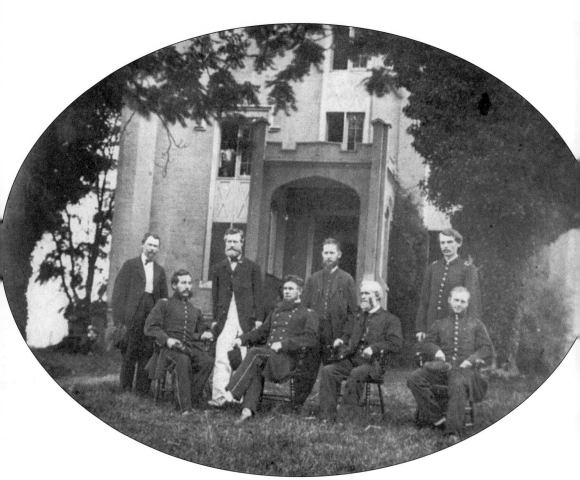

As the war progressed, the War Department took a more organized approach when it called for 300,000 troops in July of 1862 and then 300,000 more in August. The federal government warned of a draft if state quotas were not met. Springfield had an obligation of 250 men under each call, and the city set about raising money for the bounties to attract new volunteers. Massachusetts met the 1862 quota, but new demand in 1863 finally brought the draft. These Springfield soldiers sat for this photograph around 1863. (Courtesy of the Connecticut Valley Historical Museum.)

The Tenth Infantry, veterans of World War I, march up Chestnut Street on November 14, 1932. They proceeded into the Christ Church Cathedral for a service in observance of Armistice Day. The entire city was behind the soldiers that it sent into this war. The factories were busy, and women at home knitted sweaters and socks for the soldiers and maintained vegetable gardens to add to the country's food supply. (Courtesy of Christ Church Cathedral.)

BIBLIOGRAPHY

D'Amato, Donald. *Springfield—350 Years. A Pictorial History*. Norfolk, VA: The Donning Company, 1985.

Frisch, Michael H. *Town into City*. Cambridge, MA: Harvard University Press, 1972.

Gelin, James A. *Starting Over, The Formation of the Jewish Community of Springfield, Massachusetts, 1840-1905*. Lanham, MA: United Press of America, 1984.

Konig, Michael F. and Martin Kaufman, eds. *Springfield, 1636-1986*. Springfield, MA: Springfield Library and Museums Press, 1987.

Loesch, Robert. *The Interfaith Religious Heritage of Springfield, Massachusetts, 1636-1993*. Springfield, MA: Creative Publishing, 1993.